"This spring, as never before in modern times,
London is switched on. Ancient elegance and new
opulence are all tangled up in a dazzling blur
of op and pop."

„*In diesem Frühling ist London so trendbewusst*
wie nie zuvor in modernen Zeiten. Traditionsreiche
Eleganz und neue Opulenz fließen zu einer
überwältigenden Mischung aus Op- und Pop-Art
zusammen."

«*Ce printemps, comme jamais auparavant,*
Londres s'est allumée. L'ancienne élégance et la
nouvelle opulence croulent ensemble sous une
masse d'op et de pop art.»

Time magazine, 15 April 1966

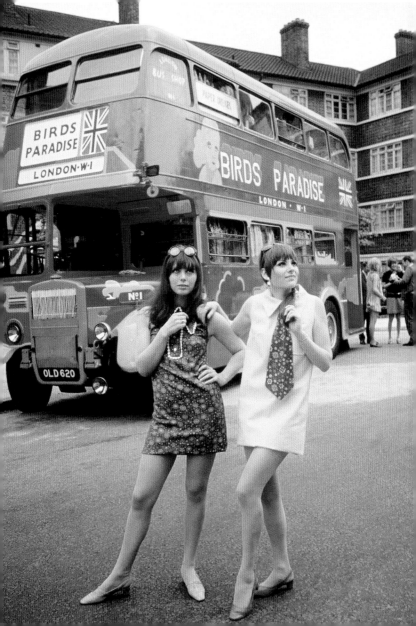

Reuel Golden

Captions written
by Barry Miles

London

Portrait of a City · Porträt einer Stadt · Portrait d'une ville

TASCHEN

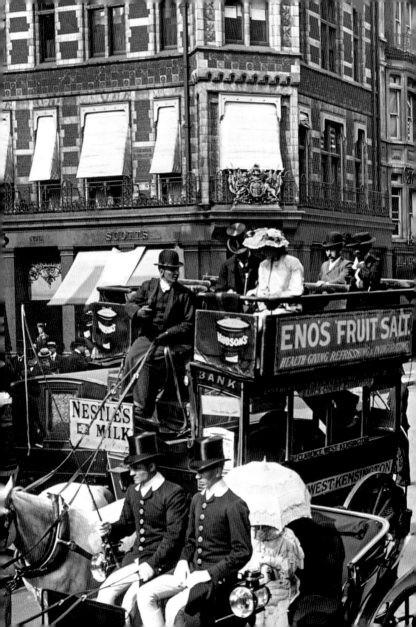

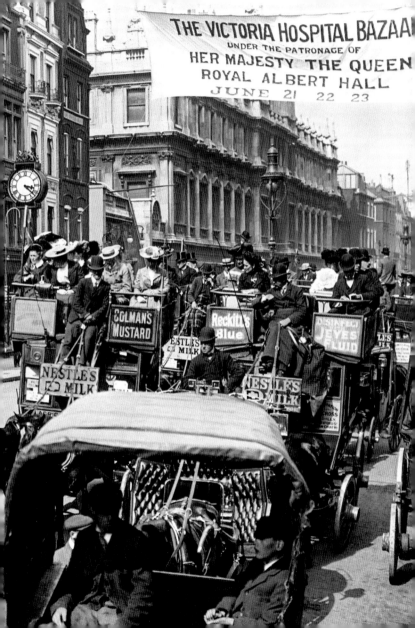

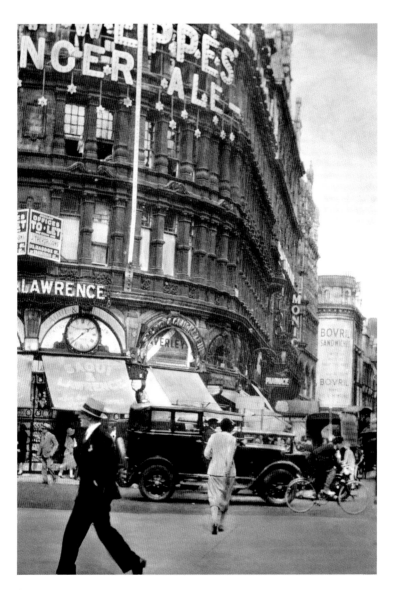

London Calling

by Reuel Golden

The Monster City 1837–1901

When Queen Victoria started her long reign, in 1837, London was the biggest city in the world by some distance, and *the* industrial city of the 19th century. Yet this was just the start: in the 100 years that followed, the city's population grew from under one million to around six million. Greater London covered nearly 70 square miles and grew at such a pace that then, as indeed today, it was hard to say precisely where it ended.

It wasn't just the city's size that drew parallels with a 'monster'; it was also that it couldn't be controlled. The pattern of London's sprawl was partly linked to changing forms of transport, the first being the arrival of the omnibus in 1829. Trams were the next major development. Introduced to London in 1860, they were first pulled by horse but by 1901 they were powered by electricity. Growth accelerated with the coming of the suburban train. By 1863 Londoners had the option of taking the world's first steam-powered underground train, and in 1890 the 'Tube', the city's distinctive, sprawling train network, came into being, and was usually on time.

"The industrial city was bound to be a place of problems. Economic individualism and common civic purpose were difficult to reconcile," according to historian Asa Briggs in *Victorian Cities*. And so the task of making London life tolerable was left to ingenious individuals, to men like Sir Joseph Bazalgette, chief engineer of the Metropolitan Board of Works, who was responsible for arguably the most impressive example of engineering in Victorian London: the city's sewer system.

Much of the architecture reinterpreted historical styles, but more forward-looking was the Crystal Palace, built for the Great Exhibition held in Hyde Park in 1851.

This glass and metal structure housed 14,000 exhibitors and welcomed over six million visitors. The city was the literary, theatrical, intellectual and scientific capital of the world, and the Great Exhibition crystallised everything that London – and Great Britain – represented, with an influx of foreign visitors generating a revolutionary tourist industry.

London could rightfully claim it was the greatest city in the world – in command of all that matters, and (in theory at least) even time, writes Roy Porter in his gripping *London: A Social History*, after the creation of the Greenwich Meridian in 1884 at the Royal Observatory in South London.

Modern Times 1902–1938

The demolition and rebuilding of central London that so dominated the previous era was, at last, consolidated, and to this day inner London largely retains its Victorian ambience. But the capital did not stand still.

The sprawl continued inexorably, helped by the Underground's expansion, and the addition of new over-ground train routes as well as a network of buses and trams reaching the suburbs. In 1904 the first motorised bus was introduced; in 1911 came the B-type double-decker; by the early 1920s more Londoners were travelling by bus than tram or Underground, and sitting on the top deck became a quintessential London experience.

A new tone for the capital's shops was set with the establishment of Selfridges (1909) in Oxford Street. Founded by an American retailer, this department store introduced a shopping experience to savour, rather than endure. Also from across the Atlantic came 'movies' that over time killed off the traditional music halls.

Responding to technological breakthroughs, in 1922 the British Broadcasting Corporation (BBC) began transmitting from Savoy Hill with the immortal words: "London calling". It was the voice of the establishment, offering home entertainment but also comfort to a city recovering from the First World War. Over 100,000 Londoners died in battle, and bombing raids killed several hundred.

Protests and demonstrations also characterised this period. The suffragettes' struggle culminated with the 1918 Representation of the People Act, which gave women of property over the age of 30 the right to vote. The biggest challenge to law and order was the ten-day General Strike of 1926, when workers from London's main industries backed the industrial action of coal miners based hundreds of miles north.

Modernity also meant flirting with 20th-century political extremism. There were communists, anarchists and the British Union of Fascists, founded by Sir Oswald

Mosley. While the rhetoric of fascism had a certain appeal to the disenfranchised, ultimately its message contravened London's sense of fair play and acceptance of diversity. Mosley's antics became irrelevant as the shadow of global conflict loomed again.

The Consequences of War 1939–1959

There was a year-long lull between the declaration of war and Hitler issuing orders to attack London yet, when the first occurred, on 7 September 1940, the capital seemed exposed and ill-prepared. The 'big Blitz' continued until spring 1941. Its initial aim was to destroy London's industrial might, so the docks and the East End were targeted; it then entered a second phase, now widespread and indiscriminate. The West End, Houses of Parliament and Buckingham Palace were hit, prompting the Queen to remark: "I'm glad we've been bombed. Now we can look the East End in the face."

By 1943 London no longer felt like a city under siege, yet this proved to be a calm before the storm. First came the 'little Blitz' in early 1944; then V1s, known as 'doodlebugs', pilotless planes that exploded on impact; and finally V2s, revolutionary silent ballistic rockets. On 8 May 1945, VE Day, Prime Minister Winston Churchill stood on a balcony in Whitehall and told the roaring crowds, "This is your victory", and they shouted back, "No, it's yours!"

Post-war London was a bleak and damaged city, but the 1948 Olympic Games were one attempt to get it back on track, although in hindsight it seems remarkable the capital could contemplate hosting such an event. There was the Queen's coronation in 1953, which the BBC transmitted via a live broadcast – for many Londoners their first experience of television – and the ambitious 1951 Festival of Britain, a commemoration of the Great Exhibition of 1851 to lift the post-war gloom.

By the mid-1950s, the economy was prospering; the Port of London was having its swansong, benefiting from this rise of mass consumerism, new markets and free-flowing international trade. People, in particular the younger generation, had money in their pockets, leading Conservative Prime Minister Harold Macmillan to declare in 1957: "You've never had it so good." With money came a youthful confidence and inclination to rebel. The 'Teddy Boys' who emerged from London's working-class districts are an early example of the important role that London's tribal subculture plays in the life of the city.

The other cultural shift was London's emergence as a more ethnically diverse city. Immigration intensified as West Indians arrived to fill vacant jobs, primarily

in the National Health Service and London Transport. They settled in areas such as Brixton in South London and Notting Hill Gate in West London, where, in 1958, London experienced its first race riots, waged between Teddy Boys and local immigrants.

The Party and the Morning After 1960–1981

Even as it was taking place people debated the precise moment when London's radical transformation began. In truth, there was no single defining factor but a combination of many.

The Beatles had shown that speaking with regional accents didn't have to be a hindrance; it was an integral part of their identity. Their success cleared the path for a new breed of working-class Londoners, which included photographer David Bailey, actor Michael Caine, hairdresser Vidal Sassoon and others who thrived in advertising, publishing, public relations, fashion and the music business. These interdependent, creative industries intensified the sense of London as the epicentre of bold and groundbreaking self-expression and by the mid-1960s it was the trend-setting capital of the world, with Carnaby Street and Chelsea, in particular King's Road, its two focal points.

In the late 1960s and into the 1970s squatters moved into abandoned properties in the inner city and set up alternative hippy communities. More conventional were middle-class Londoners who bought and restored old residences in unfashionable neighbourhoods. Unbelievable as it sounds today, bargains could be found in Islington, Camden Town, Clapham and Notting Hill, all of which experienced the gradual encroachment of gentrification.

The party, however, inevitably stopped. One can speculate as to the reasons behind its demise: The Beatles splitting up, high taxes that drove artists into exile, the Conservative party returning to power in 1970, the re-emergence of natural British cynicism.

The collective hangover was exacerbated by the city's stark economic decline. In human terms, this was reflected in rising levels of unemployment – 300,000 by 1981. Stanley Kubrick's futuristic *A Clockwork Orange*, largely filmed on location in London, is one artefact of this bleak period, as is punk rock's cynicism and amphetamine-driven music. The sound of punk originated in New York, but its aesthetic was a product of London. Clothing designer Vivienne Westwood and Sex Pistols manager Malcolm McLaren created the look of punk in their boutique SEX, at 430 King's Road. From here, the scene grew into a major cultural phenomenon.

p. 6
K. Urban
Looking north-east up Shaftesbury Avenue from Piccadilly Circus, 1933.

Blick nach Nordosten in die Shaftesbury Avenue vom Piccadilly Circus aus, 1933.

Vue au nord-est de Shaftesbury Avenue depuis Piccadilly Circus, 1933.

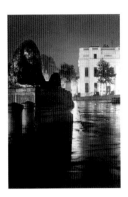

→
Anonymous
A wet night in Trafalgar Square. Despite the rain, a row of taxis wait on the west side of the square, 1910.

Eine regennasse Nacht am Trafalgar Square. Trotz des Wetters wartet eine ganze Reihe von Taxis auf der Westseite des Platzes auf Kunden, 1910.

Nuit pluvieuse à Trafalgar Square. Malgré la pluie, une file de taxis attend du côté ouest de la place, 1910.

By 1966 around 100,000 Indians and Pakistanis were living in Greater London. On a stereotypical level, the Asian-owned 'corner shop' became a feature of the city, as did the Indian restaurant. More profoundly Asians, as all immigrant groups, vastly enriched the city, creating a more vibrant, multicultural London, which today remains one of its defining, most appealing characteristics.

New Perspectives 1982 – THE PRESENT

It is now hard to recall how divided the city was in the 1980s under Prime Minister Margaret Thatcher. 'Thatcherism' was an economic, political and social philosophy underpinned by the Victorian doctrine of self-improvement. On the downside, funds for housing, education and policing were drastically cut, resulting in thousands of homeless in 'cardboard cities' and vandalised, isolating and drug-ridden housing estates. In its favour there was a spirit of entrepreneurship and greater social mobility.

The London Docklands Development Corporation was created in 1981, with a brief to turn abandoned land into a new centre of business and commerce. It allowed London to surpass Tokyo and New York by having two financial centres, one in Canary Wharf and one within the City, itself tailor-made for the new electronic dealing methods introduced in the 1986 'Big Bang' deregulation.

In the 1990s, as in the 1960s, London pulsated with a sense of purpose and creativity. The city appeared overflowing with self-confident, commercially astute, energetic, inventive young people, yet, unlike the 1960s, tinged with a knowing cynicism. The YBAs (Young British Artists) led by Damien Hirst, and their patron

saint, art collector/curator and advertising mogul Charles Saatchi, became rowdy ambassadors of Cool Britannia, while Prime Minister Tony Blair's New Labour was perfectly in sync with the times. During Blair's tenure incredible architectural and cultural icons – including Tate Modern, London Eye, Swiss Re Building, aka 'the Gherkin' – were either constructed or revamped. London at last had a skyline that matched its status as a global city.

By the middle of the last decade, the city had an aura of greatness, and was a key player and beneficiary of the booming global economy. Employment opportunities led to a huge influx of new immigrants, making it one of the most diverse cities on earth. It wasn't just ordinary people looking to better themselves; beautiful period properties, private schools, tax breaks and a laissez-faire attitude appealed to the super-rich.

Such was London's place on the world stage when it was destined to host the 2012 Olympic Games. Scenes of jubilation followed news of its winning bid, but 24 hours later a tragic comedown followed as the city experienced its worst-ever terrorist attack. On 7 July 2005 a gang of British Islamist extremists synchronised three suicide bombs on the Underground and one on a bus, killing 52 people. It took time to get over 7/7, but London's spirit will always prevail, and the 2012 London Olympics turned out to be a remarkable success on every level.

This is London: a city of extremes. It changes from day to day and, in the case of the weather, from hour to hour, always confounding expectations. London is hard to work out, but easy to love.

→
Anonymous
The Clock Tower housing Big Ben and the Palace of Westminster, 1939.

Der Clock Tower mit Big Ben und dem Palace of Westminster, 1939.

La tour de l'Horloge abritant Big Ben et le palais de Westminster, 1939.

p. 14
Ken Russell
'Teddy Girl'. A formal outfit, inspired by the mid-1950s 'Teddy Boy' look, which was in turn inspired by the clothes of Edwardian gentlemen, 1955.

„Teddy Girl". Das elegante Kostüm erinnert an die Mode der Teds Mitte der 1950er-Jahre, die wiederum von der Herrenkleidung aus der Zeit König Edwards VII. inspiriert war, 1955.

« Teddy Girl » – tenue BCBG complète, inspirée du look « Teddy Boy » du milieu des années 1950, lequel s'inspirait pour sa part de la mode masculine de l'ère edwardienne, 1955.

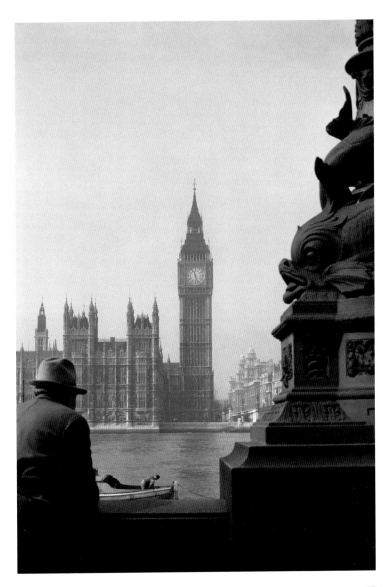

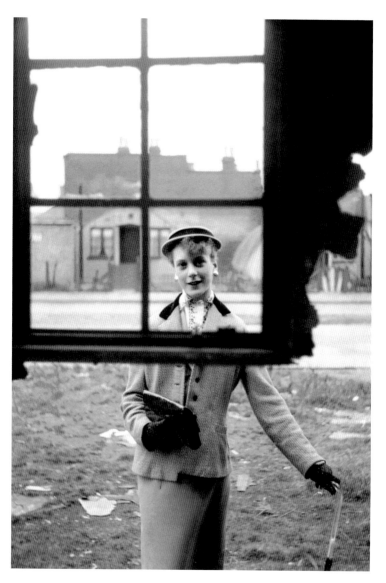

London calling

von Reuel Golden

Die Monsterstadt 1837–1901

Als Königin Victoria im Jahr 1837 ihre lange Regentschaft antrat, war London die bei Weitem größte Stadt der Welt und die bedeutendste Industriestadt des 19. Jahrhunderts. Doch das war nur der Anfang. In den folgenden 100 Jahren schwoll die Bevölkerung der Stadt von unter einer Million auf rund sechs Millionen zu Anfang des 20. Jahrhunderts an. Der Großraum London nahm eine Fläche von gut 180 Quadratkilometern ein und dehnte sich in einem Tempo aus, dass man, wie auch heute noch, kaum sagen konnte, wo genau seine Grenzen verliefen.

Doch es war nicht nur die Größe dieser Stadt, in der sie einem Monster glich, sondern auch die Tatsache, dass sie einfach nicht zu kontrollieren war. Das Muster, nach dem sich London in sein Umland fraß, war zum Teil bedingt durch den Wandel der Verkehrssysteme, der mit der Einführung des Omnibusses im Jahr 1829 seinen Anfang nahm. Als nächste große Neuerung wurde 1860 die erste Straßenbahn eingesetzt, zunächst von Pferden gezogen und ab 1901 elektrisch angetrieben. Das Wachstum der Stadt beschleunigte sich mit der Ankunft des Vorortzuges. 1863 ging der erste dampfgetriebene U-Bahnzug in Betrieb und 1890 dann die *Tube*, Londons unverwechselbares, sich unablässig ausdehnendes, und in der Regel pünktliches U-Bahnnetz.

„In der Industriestadt waren die Probleme vorgezeichnet. Ökonomischer Eigennutz und städtischer Gemeinsinn waren nur schwer in Einklang zu bringen", so der Historiker Asa Briggs in seinem Buch *Victorian Cities*. Also blieb die Aufgabe, das Leben in London erträglich zu gestalten, einzelnen genialen Persönlichkeiten überlassen: Männern wie Sir Joseph Bazalgette, Chefingenieur der städtischen Baubehörde

Metropolitan Board of Works, der für das wohl beeindruckendste Stück Ingenieurs-kunst im viktorianischen London verantwortlich war, das städtische Abwassersystem.

Die Architektur der Stadt orientierte sich zumeist an älteren Stilepochen. Zukunftsweisender war der Crystal Palace, der für die erste Weltausstellung 1851 im Hydepark errichtet wurde. Diese Konstruktion aus Glas und Metall beherbergte 14 000 Aussteller und empfing über sechs Millionen Besucher. London war die kulturelle Hauptstadt der Welt, literarisch wie künstlerisch, intellektuell wie in der Wissenschaft, und die Weltausstellung war der Inbegriff all dessen, was London – und Großbritannien – repräsentierte. Gleichzeitig ließ ihr unaufhörlicher Strom an ausländischen Besuchern eine völlig neue Tourismusindustrie entstehen.

London konnte mit Fug und Recht von sich behaupten, die bedeutendste Stadt der Welt zu sein – Herrscherin über alle wichtigen Dinge, sogar (zumindest theoretisch) über die Zeit, nachdem man 1884 entschieden hatte, den Nullmeridian durch die Königliche Sternwarte von Greenwich im Süden Londons verlaufen zu lassen. So jedenfalls beschreibt es Roy Porter in seinem fesselnden Buch *London. A Social History*

Moderne Zeiten 1902–1938

Die Zerstörung und der Neuaufbau der Londoner City, die für die vorangegan-gene Epoche so prägend waren, wurden schließlich gestoppt, sodass die Innen-stadt ihr viktorianisches Flair bis heute im Großen und Ganzen behalten hat. Und dennoch stand die Hauptstadt nie still.

Ihr Wachstum setzte sich unaufhaltsam fort, angetrieben durch die Erweiterung des U-Bahnnetzes und die Schaffung neuer Bahnstrecken sowie eines Geflechts von Bus- und Straßenbahnlinien, das die Vororte mit dem Zentrum verband. Im Jahr 1904 wurde der erste motorgetriebene Bus eingeführt, 1911 der „B-Type"-Doppel-deckerbus. Bereits in den frühen 1920er-Jahren fuhren mehr Londoner mit dem Bus als mit U-Bahn oder Straßenbahn, und auf dem Oberdeck einer dieser Busse zu sitzen wurde zur Ur-Londoner Erfahrung.

In der Londoner Geschäftswelt wurde mit der Eröffnung von Selfridges 1909 in der Oxford Street ein neuer Ton angeschlagen. Gegründet von einem US-amerika-nischen Geschäftsmann, machte dieses Kaufhaus aus der Notwendigkeit des Ein-kaufens ein Erlebnis. Ebenfalls von jenseits des Atlantiks kommend, eroberte das Kino die Stadt und verdrängte mit der Zeit die alteingesessenen Varietétheater.

Im Zuge neuer technologischer Errungenschaften sendete die British Broad-casting Corporation (BBC) 1922 ihre erste Rundfunkübertragung vom Savoy Hill

und leitete sie mit den unvergessenen Worten „London calling" ein. Es war die Stimme des Establishments, die Unterhaltung für das eigene Zuhause bot und zugleich Trost für eine Stadt, die sich noch immer nicht von den Folgen des Ersten Weltkriegs erholt hatte. Über 100 000 Londoner waren auf den Schlachtfeldern umgekommen und Hunderte von Menschen bei Bombenangriffen gestorben.

Auch Proteste und Demonstrationen prägten diese Zeit. Der Kampf der Suffragetten für die Rechte der Frau führte schließlich zur Verabschiedung des Representation of the People Act (Volksvertretungsgesetz) von 1918, das wohlhabenden Frauen über 30 Jahren das Wahlrecht zugestand. Die größte Herausforderung für den Erhalt der öffentlichen Ordnung war jedoch der Generalstreik von 1926, mit dem Arbeiter aus Londons wichtigsten Industrien die Bergarbeiterproteste einige Hundert Kilometer weiter im Norden unterstützten.

Die Moderne brachte zugleich aber auch zunehmendes Interesse am politischen Extremismus des 20. Jahrhunderts mit sich. Da gab es die Kommunisten, die Anarchisten und die Faschisten der von Sir Oswald Mosley gegründeten British Union of Fascists. Während die Parolen der Faschisten bei den gesellschaftlich Benachteiligten durchaus auf fruchtbaren Boden fielen, verletzten ihre Botschaften letztendlich doch den Sinn der Londoner für Fairness und ihr Bekenntnis zur Vielfalt. Als sich die Schatten eines neuen Weltkriegs über Europa legten, verloren Mosleys Possen zunehmend an Bedeutung.

Die Folgen des Krieges 1939–1959

Zwischen der Kriegserklärung und Hitlers Befehl, London anzugreifen, verging ein Jahr der Ruhe, doch als dann am 7. September 1940 die ersten Bomber über der Stadt auftauchten, wirkte London verwundbar und kaum vorbereitet. Der „London Blitz" dauerte bis ins Frühjahr 1941 an. Sein ursprüngliches Ziel war die Zerstörung von Londons Schlüsselindustrien, weshalb zunächst die Docks und das East End angegriffen wurden. Daran schloss sich eine zweite Phase an, in der flächendeckend und wahllos Bomben fielen. Das West End, das Parlamentsgebäude und der Buckinghampalast wurden getroffen, was die Königin zu der Bemerkung veranlasste: „Ich bin froh, dass wir bombardiert wurden. Nun kann ich meinem Volk wieder ins Gesicht sehen."

Im Jahr 1943 wirkte London nicht länger wie eine belagerte Stadt, doch dies war nur die Ruhe vor dem Sturm. Anfang 1944 rollte eine weitere Welle von Luftangriffen über die Stadt; dann folgten die lauten V1-Raketen, von den Londonern „Doodlebugs" genannt, unbemannte Flugkörper, die beim Aufprall auf den Boden

explodierten; und schließlich die V2-Raketen, völlig neuartige ballistische Marsch-flugkörper, die man erst beim Einschlag hörte. Am 8. Mai 1945, dem V-E-Day (Victory in Europe Day), stand Premierminister Winston Churchill auf dem Balkon in Whitehall und rief der jubelnden Menge zu: „Dies ist euer Sieg!" und die Menge rief zurück: „Nein, es ist Ihrer!"

Das Nachkriegslondon war eine trostlose und verwüstete Stadt, und die Olympischen Spiele von 1948 waren der Versuch, ihr wieder Leben einzuhauchen, auch wenn es in der Rückschau seltsam erscheint, wie man überhaupt auf den Gedanken kommen konnte, in der Stadt ein solches Großereignis auszurichten. Die Krönung von Königin Elisabeth im Jahr 1953, die von der BBC live übertragen wurde – für viele Londoner der erste Kontakt mit dem Fernsehen –, und das ambi-tionierte Festival of Britain im Jahr 1951, eine Veranstaltung zum 100. Jubiläum der ersten Weltausstellung von 1851 halfen, die düstere Nachkriegsstimmung etwas aufzuhellen.

Mitte der 1950er-Jahre florierte die Wirtschaft wieder; der Londoner Hafen erlebte eine letzte Blütezeit, indem er vom aufkommenden Massenkonsum, den neuen Märkten und dem Freihandel profitierte. Die Menschen, besonders aus der jüngeren Generation, hatten wieder Geld in den Taschen, was den konservativen Premierminister Harold Macmillan 1957 zu dem Ausspruch verleitete: „Ihr hattet es niemals so gut wie heute." Gemeinsam mit dem Geld kamen ein jugendliches Selbstvertrauen und der Hang zum Rebellentum. Die Teddy Boys oder Teds, die aus Londons Arbeitervierteln stammten, sind ein frühes Beispiel für die wichtige Rolle, die die Subkulturen für das Leben der Stadt spielen.

Der andere kulturelle Umbruch war Londons Wandel zu einer ethnisch vielfäl-tigeren Stadt. Die Zuwanderung stieg an, als vermehrt Menschen aus der Karibik ins Land kamen, um freie Arbeitsplätze vornehmlich im Gesundheitssystem und bei den Londoner Verkehrsbetrieben zu besetzen. Sie ließen sich in Gegenden wie Brixton im Süden der Stadt und Notting Hill Gate im Westen nieder, wo London 1958 seine ersten Rassenunruhen erlebte, die zwischen Teds und dort lebenden Migranten aufflammten.

Die Party und der Morgen danach 1960–1981

Der Prozess war noch in vollem Gang, da diskutierten die Menschen bereits über den genauen Zeitpunkt, an dem der radikale Wandel Londons begann. In Wirklich-keit lässt er sich nicht an einem einzelnen Ereignis festmachen, sondern zeigt sich im Zusammenspiel von vielen.

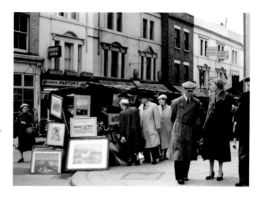

Die Beatles hatten den Beweis erbracht, dass ein regionaler Dialekt nicht unbedingt ein Hindernis auf dem Weg nach oben war, sondern vielmehr Teil einer regionalen Identität. Ihr Erfolg ebnete den Weg für eine neue Generation von Londoner Arbeiterkindern wie den Fotografen David Bailey, den Schaupieler Michael Caine oder den Haardesigner Vidal Sassoon und anderen, die in Werbung, Verlagswesen, Öffentlichkeitsarbeit, Mode oder im Musikgeschäft reüssierten. Diese unabhängigen und kreativen Branchen verstärkten die Wahrnehmung Londons als das Epizentrum einer kühnen, revolutionären Selbstdarstellung, und Mitte der 1960er-Jahre war London die Stadt, die mit ihren beiden Dreh- und Angelpunkten, der Carnaby Street und Chelsea, besonders der dortigen King's Road, in der ganzen Welt die Trends setzte.

In den späten 1960er- bis hinein in die 1970er-Jahre zogen Hausbesetzer in verlassene Gebäude in der Innenstadt, um dort Hippiekommunen zu gründen. Konventioneller verhielten sich Londoner Bürger aus der Mittelschicht, die alte Häuser in weniger beliebten Wohngegenden kauften und renovierten. Auch wenn man es heute kaum glauben mag, damals konnte man in Islington, Camden Town, Clapham und Notting Hill noch Schnäppchen schlagen, in Vierteln, die mittlerweile sämtlich von der Aufwertung überformt wurden.

Doch irgendwann war die Party unweigerlich zu Ende. Man kann über die Gründe der Ernüchterung nur spekulieren: Die Trennung der Beatles, die hohen Steuern, die die Künstler ins Exil trieben, die Rückkehr der Konservativen an die Macht im Jahr 1970, das Wiederaufblühen des naturgegebenen britischen Zynismus.

Der kollektive Kater wurde noch verstärkt durch den drastischen ökonomischen Niedergang der Stadt. Auf der menschlichen Seite zeigte er sich in den Arbeitslosenzahlen – 300 000 waren es 1981. Stanley Kubricks dystopischer Film *Uhrwerk Orange*,

der größtenteils an Originalschauplätzen in London spielt, ist ein Produkt dieser trostlosen Epoche, ebenso wie der Zynismus des Punk-Rocks und die amphetamin-befeuerte Musik dieser Zeit. Der Sound des Punks wurde in New York geboren, doch seine Ästhetik erhielt er in London. Die Modedesignerin Vivienne Westwood und der Manager der Sex Pistols, Malcolm McLaren, verpassten dem Punk in ihrer Boutique SEX in der King's Road 430 seinen ganz eigenen Look. Von hier aus wuchs die Szene zu einem prägenden kulturellen Phänomen heran.

Um 1966 lebten etwa 100 000 Inder und Pakistanis im Großraum London. Der von Asiaten betriebene Eckladen wurde zum stereotypen Merkmal der Stadt, genauso wie die indischen Restaurants. Auf einer grundlegenderen Ebene bereicherten die Einwanderer aus Asien, ebenso wie die aus anderen Regionen, das Leben in London, indem sie eine pulsierende, multikulturelle Atmosphäre schufen, die bis heute das Selbstbild dieser Stadt bestimmt und das Leben in ihr so faszinierend macht.

Neue Perspektiven 1982–HEUTE

Es ist heute kaum mehr vorstellbar, wie gespalten London in den 1980er-Jahren unter der Regierung von Premierministerin Margaret Thatcher war. Der „Thatche-rismus" war eine ökonomische, politische und soziale Philosophie, die auf dem viktorianischen Grundsatz der Eigenverantwortung und Selbsthilfe aufbaute. Er führte zu drastischen Einschnitten in den Bereichen sozialer Wohnungsbau, Bil-dung und öffentlicher Sicherheit, sowie zu Tausenden von Obdachlosen in „Papp-kartonstädten" und zu Wohnsiedlungen, die von Vandalismus, Vereinsamung und Drogenproblemen heimgesucht wurden. An positiven Entwicklungen entstanden in dieser Zeit ein besonderer Unternehmergeist und eine größere soziale Mobilität.

Die London Docklands Development Corporation wurde 1981 mit dem Auf-trag gegründet, die brachliegenden Flächen in ein neues Zentrum für Handel und Finanzen zu verwandeln. Das erlaubte es London, an Tokyo und New York vorbei-zuziehen, indem es nun zwei Finanzzentren besaß, eines in Canary Wharf und das andere in der City, das seinerseits durch die Deregulation im Zuge des sogenannten „Big Bang" 1986 für die neuen elektronischen Handelssysteme fit gemacht wurde.

In den 1990ern schwelgte London, wie schon zuvor in der 1960er-Jahren, in einem Rausch der Zielstrebigkeit und Kreativität. Die Stadt schien vor Selbstbe-wusstsein, Geschäftssinn, Energie und erfinderischen jungen Menschen förmlich überzuquellen, doch hatte nun alles, anders als in der 1960ern, einen Anstrich von wissendem Zynismus. Die Young British Artists wurden, angeführt von Damien Hirst und ihrem Schutzheiligen, Kunstsammler/-kurator und Werbemogul Charles Saatchi,

zu den rüpelhaften Botschaftern des Cool Britannia, während die Labour-Partei von Premierminister Tony Blair voll auf der Höhe der Zeit war. In Blairs Amtszeit wurden bedeutende architektonische und kulturelle Ikonen einschließlich der Tate Modern, des London Eye oder des Swiss-Re-Gebäudes, auch bekannt unter dem Namen *gherkin* (Gurke), entweder gebaut oder umgestaltet. Am Ende verfügte London immerhin über eine Skyline, die seinem Status als Weltstadt gerecht wurde.

Gegen Mitte des vergangenen Jahrzehnts umgab die Stadt eine Aura der Größe, sie war nun ein entscheidender Mitspieler und Profiteur in der boomenden globalen Finanzwirtschaft. Interessante Jobangebote lockten erneut zahllose Zuwanderer an und ließen London endgültig zu einer der vielfältigsten Städte der Welt werden. Das waren nicht mehr nur gewöhnliche Menschen, die ein besseres Auskommen suchten; wunderschöne historische Anwesen, Privatschulen, Steuervergünstigungen und eine allgemeine Laissez-faire-Haltung waren auch für die Superreichen attraktiv.

So sehr im Mittelpunkt der Weltbühne stand London, dass es zum Austragungsort der Olympischen Spiele von 2012 auserkoren wurde. Jubelszenen begleiteten die Nachricht vom Zuschlag für die Stadt, doch nur 24 Stunden später folgte die bittere Ernüchterung, als die Stadt vom schlimmsten Terroranschlag ihrer Geschichte getroffen wurde. Am 7. Juli 2005 zündete eine Gruppe britischer Islamisten in zeitlich abgestimmten Selbtmordattentaten drei Bomben in der U-Bahn und eine in einem Bus, und 52 Menschen verloren ihr Leben. Es brauchte einige Zeit, um den Schock vom 7. Juli zu überwinden, doch Londons Geist wird immer stärker sein, und die Olympischen Spiele von 2012 waren in jeder Hinsicht ein bemerkenswerter Erfolg.

Das ist London: eine Stadt der Extreme. Sie wandelt sich von Tag zu Tag und im Hinblick auf das Wetter sogar von Stunde zu Stunde, und immer wieder wirft sie alle Erwartungen über den Haufen. London ist nur schwer zu verstehen, aber leicht zu lieben.

p. 22
Gered Mankowitz

The Rolling Stones, Primrose Hill, North London. It's an out-take from the cover shoot for their classic album Between the Buttons, *1966.*

Die Rolling Stones, Primrose Hill im Norden Londons. Ein nicht genutztes Bild vom Covershooting für ihr klassisches Album Between the Buttons, *1966.*

Les Rolling Stones, Primrose Hill, dans le nord de Londres. Il s'agit d'un cliché inédit de la séance photo réalisée pour leur album classique Between the Buttons, *1966.*

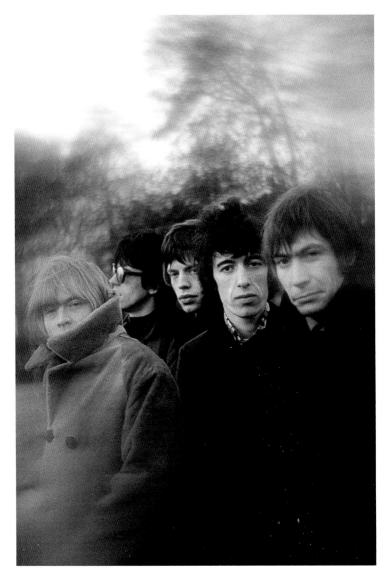

London calling

par Reuel Golden

La ville monstre 1837–1901

Au commencement du long règne de la reine Victoria en 1837, Londres était déjà la plus grande ville du monde et la capitale industrielle du XIX^e siècle. Mais ce n'était que le début puisqu'au cours de ce siècle, sa population passa de un million d'habitants à six millions environ. Le Grand Londres s'en vint à couvrir 18 000 hectares en gagnant du terrain à un tel rythme qu'il semblait difficile de dire, comme aujourd'hui d'ailleurs, où commençait exactement l'agglomération.

Ce n'était pas les seules dimensions de la ville qui appelaient à la comparaison avec un « monstre », c'était aussi le fait qu'elle devenait incontrôlable. L'extension de Londres était en partie lié aux modes de transport qui évoluèrent rapidement à partir de l'arrivée de l'omnibus à chevaux en 1829. Les tramways apparurent ensuite. Introduits en 1860, ils furent d'abord tirés par des chevaux puis alimentés par électricité à partir de 1901. La croissance s'accéléra avec l'arrivée des trains de desserte des banlieues. En 1863 on pouvait déjà emprunter le premier métro souterrain à vapeur et, en 1890, le *Tube*, l'immense réseau londonien, fut créé.

« La cité industrielle était vouée à devenir un concentré de problèmes. L'individualisme économique et le bien commun devenaient difficiles à concilier », écrit l'historienne Asa Briggs dans *Victorian Cities*. La tâche de rendre la vie tolérable aux Londoniens fut laissée à l'ingéniosité de quelques brillantes individualités. Des hommes comme Sir Joseph Balzagette, ingénieur en chef de la Commission métropolitaine des travaux publics, fut ainsi le père d'un des exemples les plus impressionnants de l'ingénierie du Londres victorien : le réseau des égouts de la ville.

Une grande partie de l'architecture se contentait de réinterpréter des styles historiques, mais le Crystal Palace, construit pour la Great Exhibition, la première des expositions universelles, organisée à Hyde Park en 1851, indiquait déjà l'évolution future. Cette structure de fer et de verre qui abritait 14 000 exposants accueillit plus de six millions de visiteurs. La ville était devenue la capitale littéraire, théâtrale, intellectuelle et scientifique du monde et la Great Exhibition cristallisait tout ce que Londres – et la Grande-Bretagne – représentait. L'afflux des visiteurs donna naissance à une véritable industrie du tourisme. Londres pouvait prétendre au titre de plus grande ville du monde, en tête de tout ce qui comptait et même, en théorie, du temps, écrit Roy Porter dans son saisissant *London. A Social History*, après l'adoption du méridien de Greenwich en 1884 à l'Observatoire royal situé dans le sud de Londres.

Les Temps modernes 1902–1938

Après la démolition et la reconstruction du centre de Londres qui avaient marqué la période précédente, on se contenta d'une consolidation et à ce jour, le centre de Londres a en grande partie conservé son atmosphère victorienne. Mais la capitale ne s'en était pas arrêtée là pour autant.

Son étalement se poursuivait inexorablement, aidé par l'expansion du métro et l'ouverture de nouvelles voies ferrées ainsi que la création d'un réseau de bus et de trams desservant les banlieues. En 1904, le premier bus motorisé fut introduit, puis, en 1911, le premier bus à impériale. Au début des années 1920 déjà, plus de Londoniens se déplaçaient en bus que par tram ou métro. Voyager assis sur l'impériale devint la manière quintessentielle et inoubliable de découvrir Londres.

Du côté du commerce, un nouvel élan fut donné en 1909 par l'ouverture de Selfridges, sur Oxford Street. Fondé par un Américain, ce grand magasin introduisait une nouvelle façon de faire ses courses, reposant davantage sur le plaisir de la découverte que sur l'obligation d'achat. De l'autre côté de l'Atlantique arrivèrent également les films qui, avec le temps, allaient tuer les music halls traditionnels.

Grâce à de nouvelles avancées technologiques, la British Broadcasting Corporation, la BBC, émit en 1922 pour la première fois depuis Savoy Hill, au son de l'annonce immortelle pour les Londoniens : « *London calling* ». C'était la voix de l'establishment qui offrait aux Londoniens le plaisir d'émissions à domicile mais, aussi, réconfortait une population éprouvée par la Première Guerre mondiale. Plus de 100 000 Londoniens étaient morts dans les batailles et les premiers bombardements en avaient tué plusieurs centaines. Des manifestations et des protestations marquèrent également cette période. Le combat des suffragettes culmina en 1918 avec la loi sur la représen

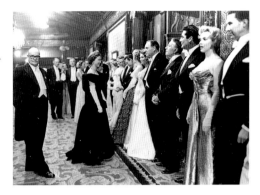

tation du peuple qui donnait aux femmes propriétaires âgées de plus de 30 ans le droit de vote. Le plus grand défi lancé à l'ordre établi fut la grève générale de dix jours en 1926 qui vit les ouvriers des principales usines londoniennes soutenir les arrêts de travail des mineurs basé à des centaines de kilomètres au nord.

La modernité entraîna aussi quelques troubles en lien avec les extrémismes du XXᵉ siècle. Il y eut des communistes, des anarchistes et la British Union of Fascists fondée par Sir Oswald Mosley. Si la rhétorique du fascisme séduisait certains, son message finit par aller à l'encontre du traditionnel sens du *fair play* et de tolérance de la diversité traditionnels chez les Londoniens. Les bouffonneries de Mosley perdirent tout attrait lorsque l'ombre d'une guerre mondiale recommença à s'étendre.

La guerre et ses conséquences 1939–1959

Il y eut un moment de répit d'un an entre la déclaration de guerre et l'ordre d'Hitler d'attaquer Londres, ce qui se produisit le 7 septembre 1940, la capitale apparaissant vite exposée et mal préparée. Le grand Blitz se poursuivit jusqu'au printemps 1941. L'objectif initial des nazis était de détruire la puissance industrielle de Londres ce qui les amena à cibler les docks et l'East End, puis, dans une seconde phase, toute la ville fut bombardée. Le quartier du West End, le Parlement et Buckingham Palace furent touchés ce qui fit dire à la reine : « Je suis contente que nous ayons été bombardés, maintenant, nous pouvons regarder l'East End en face. »

En 1943, Londres ne se sentait plus une ville en état de siège, le calme précédant la tempête. Tout d'abord vint le « petit Blitz » début 1944, puis les V1, avions sans

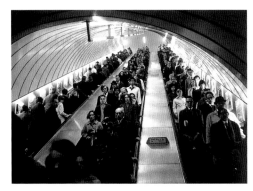

pilote qui explosaient en touchant le sol et finalement les V2, fusées balistiques révolutionnaires et silencieuses. Le 8 mai 1945, le V Day, le Premier ministre Winston Churchill apparut à un balcon de Whitehall et lança à la foule qui l'applaudissait : « C'est votre victoire », à quoi la foule lui répondit : « Non, c'est la vôtre ! »

Le Londres de l'après-guerre était une ville triste et très endommagée, mais en 1948, la tenue des Jeux olympiques fut l'occasion de la remettre sur ses rails, bien qu'aujourd'hui on se demande encore comment la capitale a pu accueillir un tel événement dans ces conditions. Il y eut ensuite le couronnement de la reine en 1953, que la BBC transmit en direct à la télévision – pour beaucoup de Londoniens leur première expérience de ce média – et l'ambitieux Festival of Britain de 1951, commémoration de l'Exposition universelle de 1851 organisée pour relever le moral de l'après-guerre.

Au milieu des années 1950, l'économie avait recouvré sa prospérité. Le port de Londres poussait son chant du cygne grâce à l'augmentation de la consommation, (devenue de masse), de l'ouverture de nouveaux marchés et d'un commerce international sans entrave. Les gens, en particulier les jeunes générations, avaient enfin un peu d'argent en poche, ce qui fit dire au Premier ministre conservateur Harold Macmillan en 1957 : « Vous n'avez jamais vécu aussi bien. » Avec l'argent les gens retrouvèrent confiance en eux et se découvrirent une certaine propension à se rebeller. Les Teddy Boys, apparus dans les quartiers ouvriers de Londres, sont un des premiers exemples du rôle important que la subculture tribale allait jouer dans la vie de la capitale.

L'autre grande évolution culturelle fut l'apparition d'un Londres ethniquement plus diversifié que jamais. L'immigration s'intensifia avec l'arrivée d'une population

issue des Caraïbes pour occuper des emplois vacants, à commencer dans le Service national de santé et les transports londoniens. Ils s'installèrent dans des quartiers comme Brixton au sud de Londres et Notting Hill Gate dans l'ouest où, en 1958, se déroulèrent les premières émeutes raciales, déclenchées entre des Teddy Boys et des immigrés de ces quartiers.

La fête et le réveil 1960–1981

Alors même que ces événements se déroulaient, les Londoniens se demandaient encore à quel moment précis leur ville avait commencé à se transformer aussi radicalement. En réalité, il n'y avait pas eu un seul facteur, mais une combinaison de plusieurs.

Les Beatles avaient montré que leur accent régional n'était plus un inconvénient. Il faisait partie intégrale de leur identité. Leur succès ouvrit la voie à une nouvelle génération de Londoniens de la classe ouvrière, dont le photographe David Bailey, l'acteur Michael Caine, le coiffeur Vidal Sassoon et d'autres qui se frayèrent le chemin de la réussite dans la publicité, l'édition, les relations publiques, la mode et les industries musicales. Ces industries créatives interdépendantes intensifièrent le sentiment que la capitale était devenue l'épicentre d'une nouvelle expression de soi, audacieuse et révolutionnaire. Vers le milieu des années 1960, elle était la capitale du renouveau mondial, avec deux lieux mythiques où tout se passait : Carnaby Street et Kings Road à Chelsea.

À la fin des années 1960 et dans les années 1970, des squatters s'installèrent dans quelques maisons vides du centre de la ville et établirent des communautés hippies. Plus conventionnels, les Londoniens de la middle-class achetèrent et restaurèrent des maisons anciennes dans des quartiers jusqu'alors là pas du tout à la mode. Aussi incroyable cela puisse paraître aujourd'hui, on pouvait faire des affaires en achetant à Islington, Camden Town, Clapham et Notting Hill, quartiers qui allaient céder peu à peu à l'embourgeoisement.

Inévitablement, la fête finit par s'arrêter. On peut spéculer sur les raisons de ce déclin : la séparation des Beatles, les impôts élevés qui poussèrent des artistes à s'exiler, le retour du parti conservateur en 1970, la réémergence du cynisme britannique.

Cette gueule de bois collective fut exacerbée par le déclin économique très net de la ville. En termes humains, il se traduisit par l'augmentation du chômage : 300 000 chômeurs en 1981. *Orange mécanique*, le film futuriste de Stanley Kubrick, en grande partie filmé en décors naturels à Londres, est l'un des produits de cette triste période comme le cynisme du punk rock et la musique nourrie d'amphétamines. Le son punk venait de New York, mais son esthétique était un produit résolument

londonien. La styliste de mode Vivienne Westwood et le manager des Sex Pistols Malcolm McLaren créèrent le look punk dans leurs boutiques SEX au 430 Kings Road. De là, le mouvement se transforma en un phénomène culturel majeur.

En 1966, environ 100 000 Indiens et Pakistanais vivaient déjà dans le Grand Londres. Selon les stéréotypes acceptés, les petites épiceries asiatiques et les restaurants indiens devinrent une des caractéristiques de la ville. Plus concrètement, les Asiatiques, comme toutes les communautés d'immigrés, enrichirent énormément la ville, donnant naissance à un Londres multiculturel animé, qui reste encore l'un des traits les plus séduisants de son caractère.

Nouvelles perspectives 1982–À NOS JOURS

Il est aujourd'hui difficile de se souvenir à quel point la ville était clivée dans les années 1980 sous la férule du Premier ministre Margaret Thatcher. Le thatchérisme était une philosophie économique, politique et sociale étayée par la doctrine victorienne de la réussite personnelle. Son aspect le plus négatif fut ses coupes budgétaires drastiques dans les domaines du logement, de l'éducation et de la police aboutissant à l'apparition de milliers de sans-abri vivant dans des «cités de carton» et un habitat social vandalisé, isolé et rongé par la drogue. En sa faveur pouvaient lui être attribué l'esprit d'entreprise et une plus grande mobilité sociale.

La London Docklands Development Corporation fut fondée en 1981 pour réhabiliter des zones des docks abandonnées et les transformer en un nouveau centre d'affaires. Elle permit à Londres de dépasser New York et Tokyo en disposant de deux centres financiers, la City et Canary Wharf, adaptés aux nouveaux modes d'échanges électroniques introduits par la dérégulation de 1986, le fameux «Big Bang».

Dans les années 1990, comme dans les années 1960, London vibrait d'un nouveau sentiment de dynamisme et de créativité. La ville donnait l'impression d'être envahie de jeunes gens inventifs, confiants en eux-mêmes, commercialement astucieux, énergiques mais, à la différence des années 1960, non sans un certain cynisme. Les YBAs (Young British Artists) menés par Damien Hirst et leur saint patron/collectionneur d'art/commissaire d'expositions et grand homme de la publicité Charles Saatchi devinrent les ambassadeurs tapageurs de la Cool Britannia, tandis que le New Labour du Premier ministre Tony Blair se retrouvait en synchronisation parfaite avec l'époque. Sous le mandat de Blair, apparurent d'incroyables icônes architecturales et culturelles, nouvelles ou restaurées, comme la Tate Modern, le London Eye, la tour Swiss Re, alias «le concombre». London enfin se dotait d'un paysage urbain en accord avec son statut de grande cité de la globalisation.

→
Peter Marlow
The Canary Wharf financial centre regenerated the abandoned dockyards in London's East End. Looking east from Wapping, 2011.

Mit dem Finanzzentrum Canary Wharf wurden die verlassenen Hafenanlagen im Londoner East End wiederbelebt. Blick nach Osten von Wapping aus, 2011.

Le centre financier de Canary Wharf a fait revivre les docks désaffectés de l'East End londonien. Vue à l'est depuis Wapping, 2011.

Au milieu de la dernière décennie, la ville se dota d'une aura de prestige et fut l'un des acteurs clés et des principaux bénéficiaires de l'essor de l'économie globale. Les opportunités d'emplois entraînèrent un énorme afflux d'immigrés, qui en fit l'une des villes les plus cosmopolites de la planète. Il ne s'agissait pas seulement de gens ordinaires cherchant une vie meilleure, ni de ces super riches attirés par les belles demeures anciennes, les écoles privées, les avantages fiscaux et une attitude générale de laisser-faire.

La situation de Londres sur la scène mondiale était telle qu'elle ne pouvait qu'accueillir les Jeux olympiques de 2012. Des scènes d'allégresse populaire suivirent l'annonce du choix de la ville, mais vingt-quatre heures plus tard, le centre de la cité connut sa pire attaque terroriste. Le 7 juillet 2005, un groupe d'extrémistes islamistes d'origine britannique synchronisa trois suicides à la bombe dans le métro et un dans un bus, tuant 52 personnes. Il fallut un certain temps pour que la vie retrouve son rythme, mais l'esprit des Londoniens reprend toujours le dessus et les Jeux olympiques de 2012 finirent par être un remarquable succès, à tous les niveaux.

Voici donc Londres : la ville des extrêmes. Elle change de jour en jour, et pour ce qui est du temps qu'il fait, d'heure en heure, s'amusant toujours à tromper les attentes. Londres est difficile à appréhender, mais si facile à aimer.

p. 30/31
Anonymous
Piccadilly Circus, looking east with the famous statue of Eros by Alfred Gilbert, 1894–1900.

Blick vom Piccadilly Circus nach Osten mit der berühmten Eros-Statue von Alfred Gilbert, 1894–1900.

Piccadilly Circus, vue à l'est avec la célèbre statue d'Éros par Alfred Gilbert, 1894–1900.

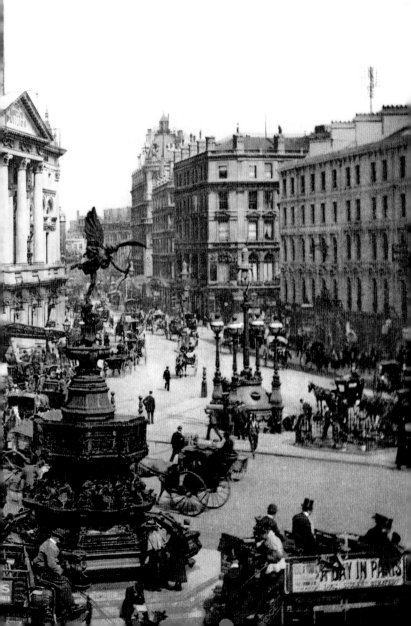

"It is a wonderful place – vast, strange, new and impossible to describe. Its grandeur does not consist in one thing, but in the unique assemblage of all things."

„Es ist ein wundervoller Ort – riesig, fremd, neu und unbeschreiblich. Diese Herrlichkeit ist nicht auf eine einzelne Sache zurückzuführen, sondern setzt sich aus einem einzigartigen Zusammenspiel aller Dinge zusammen."

« C'est un endroit merveilleux – vaste, étrange, nouveau et impossible à décrire. Son lustre ne réside pas dans une seule chose, mais dans la réunion unique de toutes choses. »

**Charlotte Brontë
on the Great Exhibition, 1851**

→
Anonymous
Home of the Great Exhibition of the Works of Industry of all Nations of 1851 in Hyde Park, the Crystal Palace, a cast-iron and glass pavilion designed by Joseph Paxton was 1,851 feet (564 m) long and 128 feet (39 m) high, 1851.

Der von Joseph Paxton entworfene und aus Gusseisen und Glas konstruierte Crystal Palace, Veranstaltungsort der Londoner Industrieausstellung im Jahr 1851 im Hyde Park, war 564 Meter lang und 39 Meter hoch, 1851.

Le Crystal Palace de Joseph Paxton, pavillon de fonte et de verre de 564 m sur 39 m qui accueillit la Great Exhibition of the Works of Industry of all Nations de 1851 à Hyde Park, 1851.

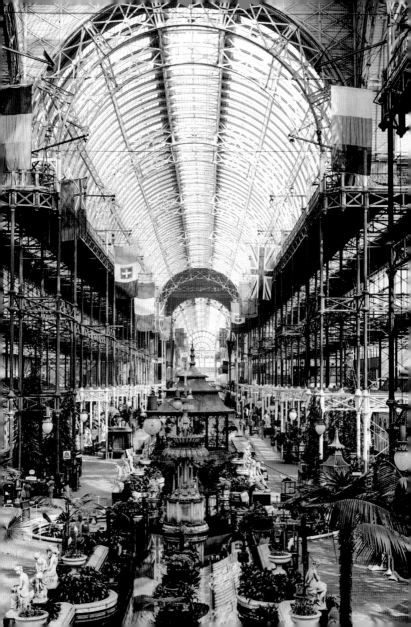

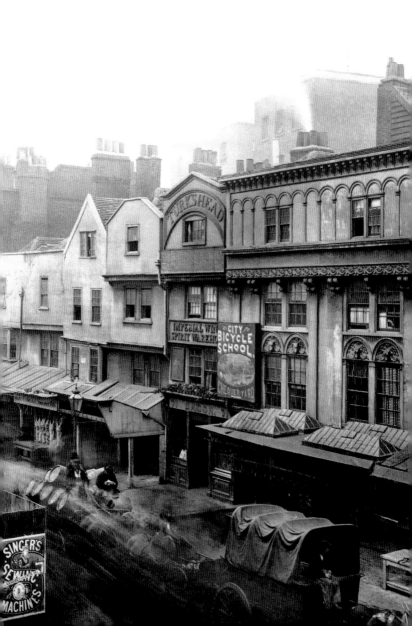

←

Henry Dixon

Many of the buildings in Aldgate were survivors of the Great Fire of 1666, some with cellars going back to the 13th century. Most have now been demolished, 1883.

Viele Gebäude am Aldgate, einige von ihnen mit Kellern aus dem 13. Jahrhundert, hatten dem Großen Brand von 1666 standgehalten. Die meisten wurden in der Zwischenzeit abgerissen, 1883.

Beaucoup de maisons d'Aldgate étaient des rescapées du Grand Incendie de 1666. Certaines avaient des caves datant du xiiie siècle. La plupart ont aujourd'hui été démolies, 1883.

↑

James Hedderley

A photograph of a quiet stretch of the Thames at Chelsea, c. 1870.

Foto eines ruhigen Abschnitts der Themse in Chelsea, um 1870.

Une photographie d'une portion paisible de la Tamise à Chelsea, vers 1870.

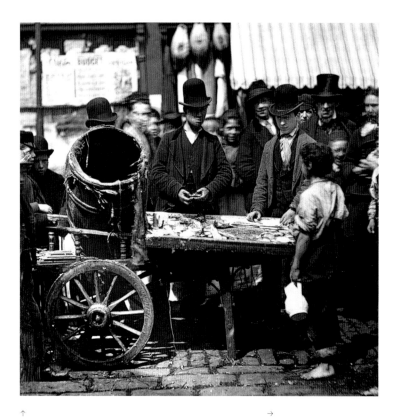

↑
John Thomson

Costermonger Joseph Carney selling fish in the street market at Seven Dials, Covent Garden, which catered to the nearby slums of St Giles. Large herrings were one penny each; small ones, a halfpenny, 1876–1877.

Der Straßenhändler Joseph Carney verkauft Fisch auf dem Markt in Seven Dials, Covent Garden; hier kauften die Menschen aus den angrenzenden Slums von St. Giles ein. Große Heringe kosteten je einen Penny, kleine einen halben, 1876–1877.

Joseph Carney, marchand de quatre-saisons, vendant du poisson au marché de Seven Dials, à Covent Garden. Ce marché alimentait les proches taudis de St Giles. Les grands harengs coûtaient un penny pièce, les petits un demi penny, 1876–1877.

→
Marion & Co.

A street performer with an act featuring cats and birds, something that would certainly not be permitted now, 1880s.

Ein Straßenkünstler führt ein Kunststück mit Katzen und Vögeln vor – das wäre heutzutage sicher nicht erlaubt, 1880er-Jahre.

Artiste de rue exécutant un numéro de chats et d'oiseaux qui serait assurément interdit aujourd'hui, années 1880.

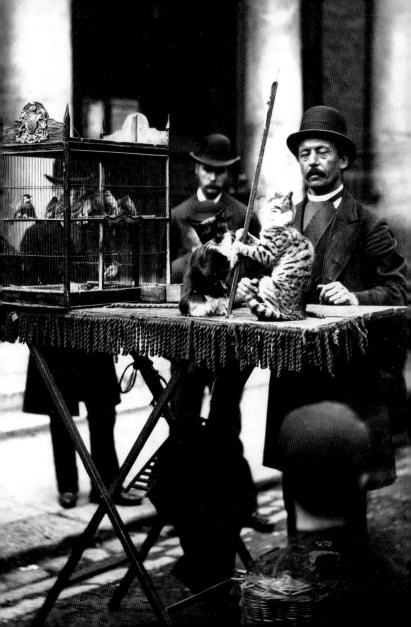

← **John Thomson**

Ted 'Coally', or 'Hookey Alf', as he was called, outside a tavern on the Whitechapel Road. The victim of an industrial accident, which cost him his hand, used his hook to unload coal sacks, 1877.

Der Mann mit dem Spitznamen Ted „Coally" oder „Hookey Alf" vor einer Taverne in der Whitechapel Road. Nachdem er eine Hand bei einem Arbeitsunfall verloren hatte, benutzte er seinen Armhaken zum Entladen von Kohlesäcken,1877.

Ted « Coally » ou « Hookey Alf », comme on le surnommait, devant une taverne de Whitechapel Road. Après la perte d'une main dans un accident du travail, il se servit de son crochet pour décharger les sacs de charbon, 1877.

↑ **Anonymous**

A Victorian Punch & Judy show, c. 1858.

Kasperletheater in Viktorianischer Zeit, um 1858.

Spectacle de marionnettes victorien, vers 1858.

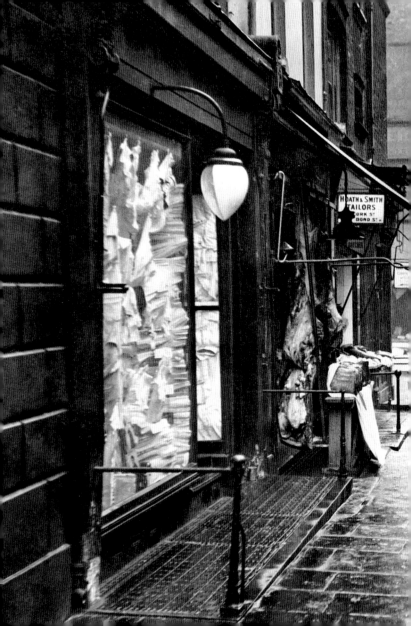

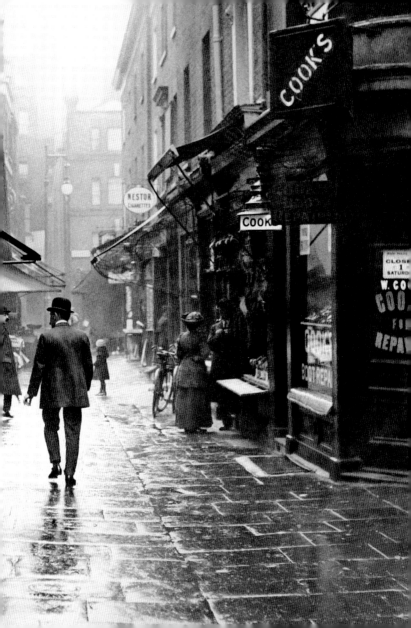

"I naturally gravitated towards London, that
great cesspool into which all the loungers and
idlers of the Empire are irresistibly drained."

„Unter diesen Umständen zog es mich natürlich
nach London, der großen Senkgrube, wo
alle Faulenzer und Müßiggänger des Empires
unweigerlich abgelagert werden."

« J'étais tout naturellement attiré vers Londres,
ce grand cloaque où sont irrésistiblement happés
tous les fainéants et les oisifs de l'Empire. »

Arthur Conan Doyle, *A Study in Scarlet*, 1887

p. 40/41
Anonymous
*A typical misty Victorian London
street scene, c. 1900.*

*Eine typische Straßenszene im
nebligen viktorianischen London,
um 1900.*

*Scène de rue typiquement embrumée
de la Londres victorienne, vers 1900.*

→
Anonymous
*Cleopatra's Needle, on the
Embankment, given to the nation
in 1819, but not transported
there until 1877, 1900.*

*Cleopatra's Needle auf dem Victoria
Embankment wurde dem Land
1819 geschenkt, aber erst 1877 nach
England transportiert, 1900.*

*L'Aiguille de Cléopâtre, sur l'Em-
bankment, fut offerte à l'Angleterre
en 1819, mais n'y fut transportée
qu'en 1877, 1900.*

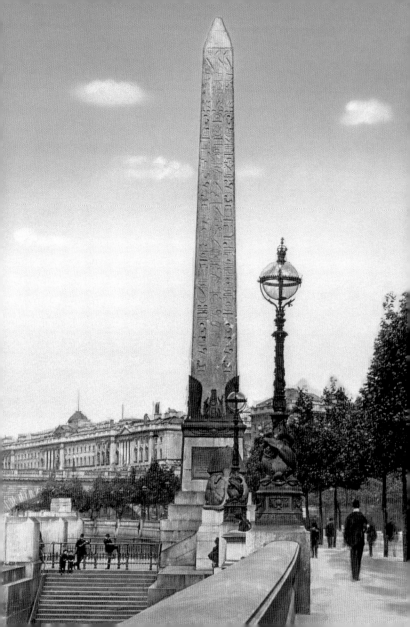

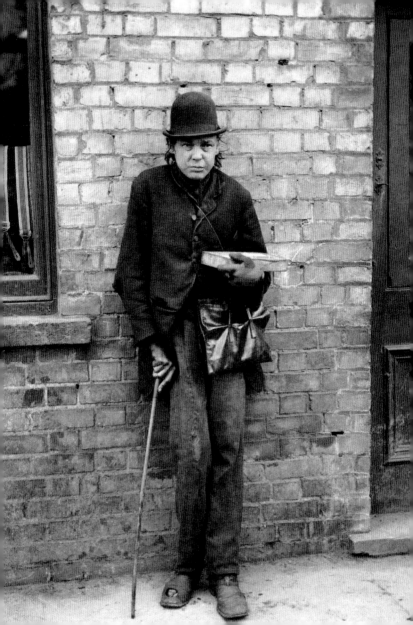

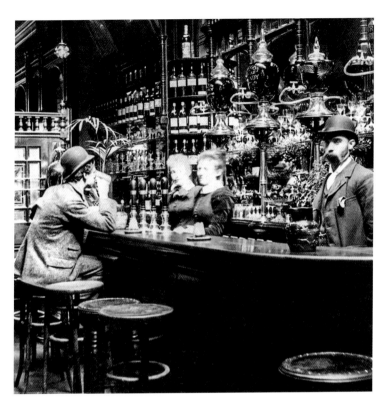

←

Edgar Scamell
A painfully thin street hawker, 1892.

Ein klapperdürrer Straßenhändler, 1892.

Un colporteur tristement famélique, 1892.

↑

Anonymous
For many Londoners, the public house was the most luxurious interior they would ever see and publicans vied with each other to install ever more mirrors, mahogany and brass fittings, 1893.

Für viele Londoner war der Pub der luxuriöseste Innenraum, den sie je zu sehen bekamen, und die Wirte konkurrierten miteinander um die prunkvollste Ausstattung mit möglichst vielen Spiegeln, Messingbeschlägen und Mahagoni, 1893.

Pour bien des Londoniens, le pub était l'intérieur le plus luxueux qu'ils pourraient jamais visiter, et les propriétaires de pubs rivalisaient d'inventivité pour installer encore plus de miroirs, d'acajou et de garnitures en laiton, 1893.

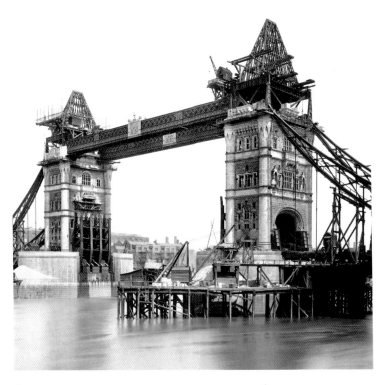

↑
Anonymous
Tower Bridge. Construction of this much-loved landmark and symbol of London began in 1886 and took eight years, 1893.

Die Tower Bridge. Der Bau dieses viel geliebten Wahrzeichens und Symbols von London begann 1886 und dauerte acht Jahre, 1893.

Tower Bridge. La construction de ce monument très populaire et symbole de Londres débuta en 1886 et dura huit ans, 1893.

→
Anonymous
Queen Victoria's Diamond Jubilee celebrations in Brixton, in the 60th year of her reign, 1897.

Feierlichkeiten zum diamantenen Thronjubiläum von Königin Victoria in Brixton, anlässlich ihrer 60-jährigen Regentschaft, 1897.

Le jubilé de diamant à Brixton, marquant les soixante ans du règne de la reine Victoria, 1897.

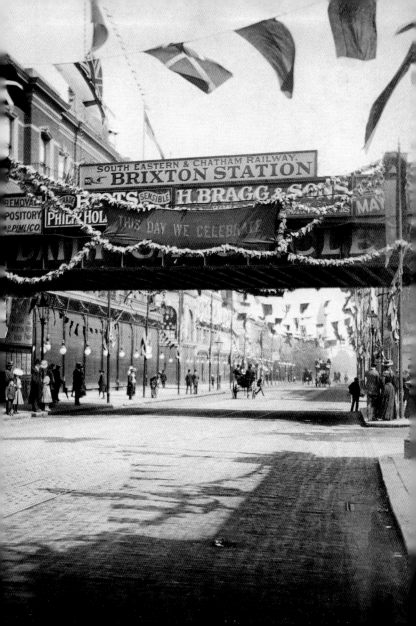

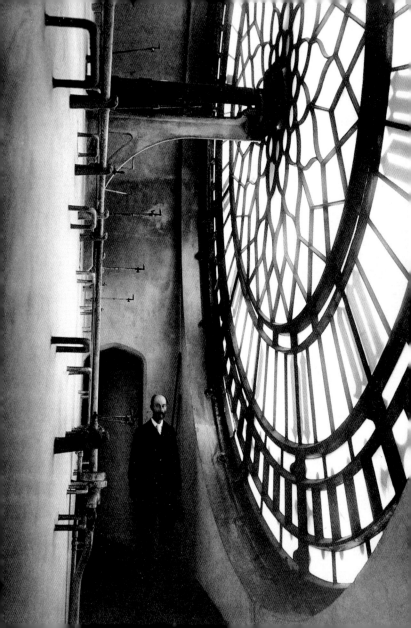

"I felt that this grey monstrous London of ours, with its myriads of people, with its sordid sinners, and its splendid sins…must have something in store for me."

„Ich empfand unser graues, ungeheures London mit seinen vielen Hunderttausenden, seinen schmutzigen Sündern und seinen glänzenden Sünden…müsse etwas für mich in Bereitschaft halten."

« Je sentis que notre Londres maussade, avec ses myriades de gens, ses pécheurs sordides et ses péchés splendides…devait bien avoir quelque chose à me réserver. »

Oscar Wilde, *The Picture of Dorian Gray*, 1891

←

John Benjamin Stone
One of the four clock faces on the Clock Tower popularly known as Big Ben. Each face is 22 feet 6 inches (6.80 m) in diameter and weighs 30 tons (30.5 tonnes), 1897.

Eines der vier Zifferblätter der Uhr des Clock Tower, im Volksmund Big Ben genannt. Jedes Zifferblatt misst 6,80 m im Durchmesser und wiegt 30,5 Tonnen, 1897.

Un des quatre cadrans de la tour de l'Horloge, plus connue sous le nom populaire de Big Ben. Chaque cadran mesure 6,80 m de diamètre et pèse 30,5 t, 1897.

p. 50/51
Anonymous
The City and South London Railway opened the world's first electric underground railway to the public in 1890.

Die City and South London Railway Company eröffnete am 18. Dezember 1890 die erste elektrische Untergrundbahn der Welt, 1890.

Le 18 décembre 1890, la City and South London Railway Company ouvrait la première ligne de métro électrifiée au public, 1890.

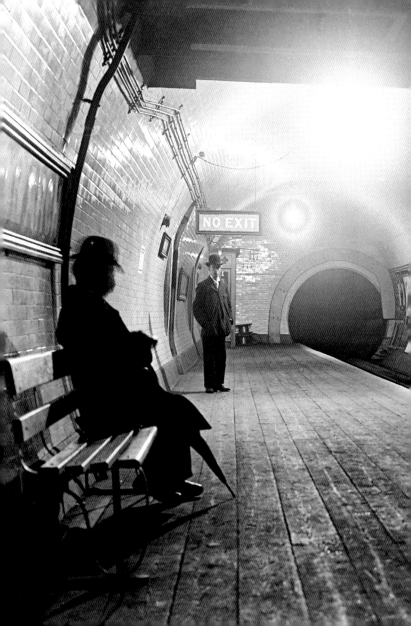

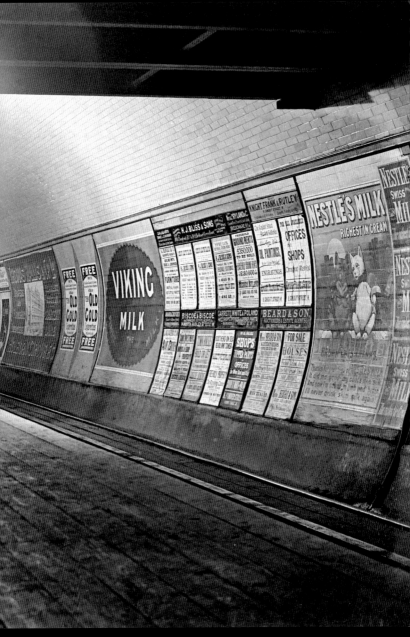

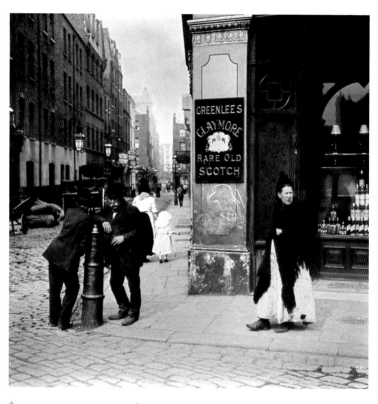

↑
Burton Holmes

*This shot of an East End pub in
1895 looks like the setting for
a Victorian costume drama, 1895.*

*Dieser Pub im East End sieht im
Jahr 1895 wie die Kulisse eines vik-
torianischen Kostümfilms aus, 1895.*

*Cette photographie d'un pub de
l'East End ressemble au décor d'une
pièce costumée se jouant à l'ère vic-
torienne, 1895.*

→
Anonymous

*This packed house is at the Hay-
market Theatre, on Haymarket, in
the heart of London's theatre district,
the area surrounding Piccadilly
Circus, 1899.*

*Dicht gedrängt sitzt das Publikum
im Haymarket Theatre am Hay-
market im Herzen des Londoner
Theaterviertels, der Gegend um den
Piccadilly Circus, 1899.*

*Cette salle pleine à craquer est
celle du Haymarket Theatre, dans
Haymarket, quartier des théâtres
de Londres situé aux abords de
Piccadilly Circus, 1899.*

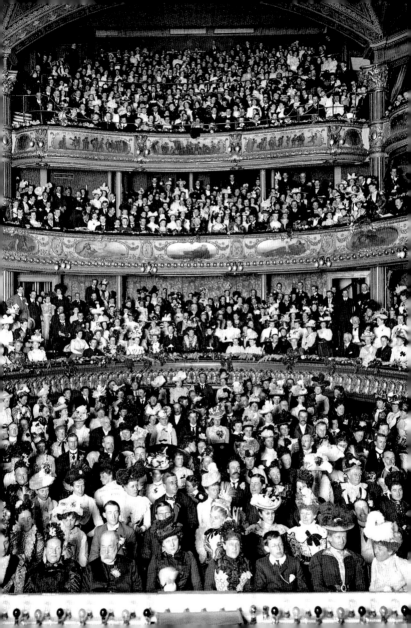

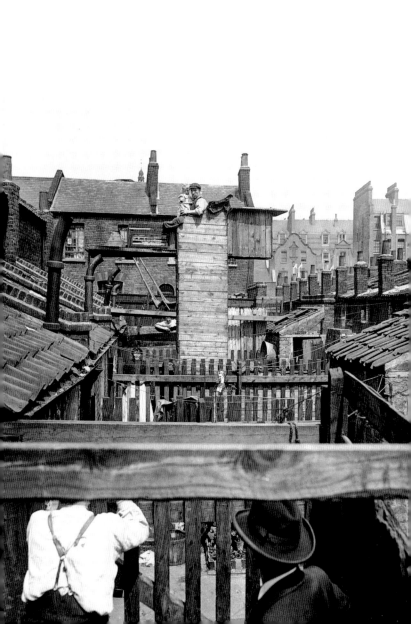

"The procession of the town's life was still rolling in through the great arteries with a sound as of a mighty wind."

„Das Leben der Stadt rollte in endloser Prozession immer weiter die großen Verkehrsadern entlang mit einem Rauschen wie von mächtigem Wind."

« La rumeur de la ville me parvenait encore par les grandes artères, comme le grondement d'un vent impétueux. »

Robert Louis Stevenson,
***Strange Case of Dr Jekyll and Mr Hyde,* 1886**

← *John Galt*
John Galt
Pigeon fanciers at their pigeon loft in Spitalfields, East London, c. 1900.

Taubenliebhaber in ihrem Tauben-schlag in Spitalfields, East London, um 1900.

Colombophiles dans leur pigeonnier à Spitalfields, à l'est de Londres, vers 1900.

p. 56/57
Anonymous
London fogs continued up until the 1950s, with the Great Smog of 1952 causing an estimated 4,000 deaths and prompting the passing of the Clean Air Act of 1956, 1930.

Die Londoner Nebel dauerten bis in die 1950er-Jahre hinein an. Der große Smog von 1952 verursachte schätzungsweise 4 000 Todesfälle und führte zur Verabschiedung des Luftreinhaltungsgesetzes von 1956, 1930.

Le fog de Londres dura jusque dans les années 1950. Selon les estimations, le « Great Smog » de 1952 fit 4 000 victimes ; il conduisit au vote du « Clean Air Act » de 1956, 1930.

"On an autumn afternoon of 1919 a hatless
man with a slight limp…might have been
observed in the great metropolitan industrial
district of Clerkenwell."

„An einem Herbstnachmittag des Jahres 1919
hätte man einen Mann, leicht humpelnd und
ohne Hut,…in Clerkenwell, dem großartigen
Industrieviertel der Stadt, beobachten können."

« Par un après-midi de l'automne 1919, un
homme tête nue, affecté d'une légère claudica-
tion,… aurait pu être aperçu dans le grand
district industriel de Clerkenwell. »

Arnold Bennett, *Riceyman Steps*, 1923

→
Anonymous
*Winston and Clementine Churchill
out walking with their youngest
child, Mary, later Baroness Soames,
1935.*

*Winston und Clementine Churchill
bei einem Spaziergang mit ihrem
jüngsten Kind Mary, der späteren
Baronin Soames, 1935.*

*Winston et Clementine Churchill
se promenant avec Mary, leur fille
cadette et future baronne Soames,
1935.*

p. 60/61
Clifton R. Adams
*The London General Omnibus
Company was formed on 1 January
1859 to operate horse-drawn services.
From 1907 all the buses were
painted red and given numbers to
differentiate their routes, 1928.*

*Die London General Omnibus Com-
pany wurde am 1. Januar 1859 für
den Betrieb von Pferde-Omnibussen
gegründet. Ab 1907 waren alle Busse
rot gestrichen und mit Nummern
versehen, damit man die Strecken
unterscheiden konnte, 1928.*

*La London General Omnibus
Company fut créée le 1ᵉʳ janvier
1859 pour administrer les services
hippomobiles : à partir de 1907,
tous les bus furent peints en rouge et
reçurent des numéros pour distinguer
leurs itinéraires, 1928.*

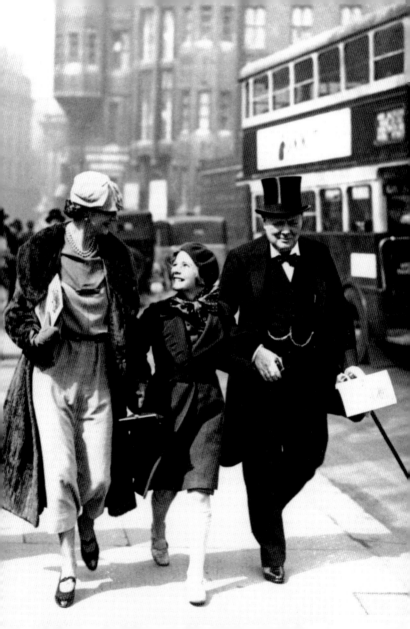

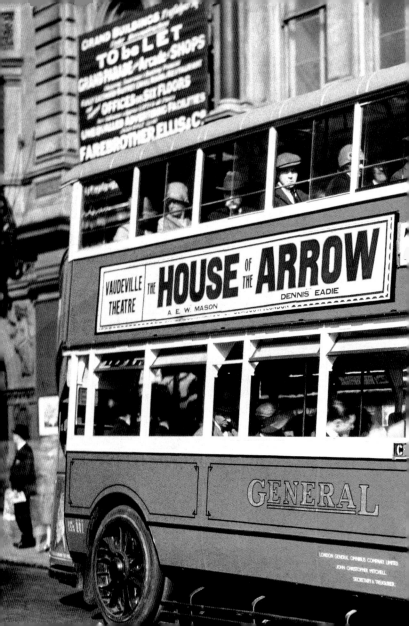

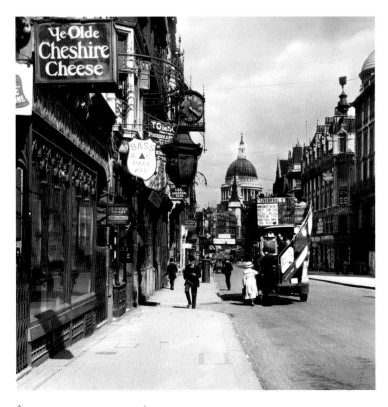

↑
Burton Holmes
*Looking east down Fleet Street
towards St Paul's Cathedral, 1919.*

*Blick nach Osten in die Fleet Street
in Richtung St. Paul's Cathedral,
1919.*

*Vue à l'est de Fleet Street vers la
cathédrale Saint-Paul, 1919.*

→
Alvin Langdon Coburn
*The west front of St Paul's Cathedral
seen from Ludgate Circus through
the smoke and steam of London. The
spire of St Martin-within-Ludgate
is in the foreground, 1906.*

*Blick von Ludgate Circus durch
Londoner Rauch und Qualm auf die
Westseite von St. Paul's Cathedral.
Im Vordergrund sieht man den
Turm der Kirche St. Martin-within-
Ludgate, 1906.*

*La façade ouest de la cathédrale
Saint-Paul vue de Ludgate Circus à
travers la fumée et les vapeurs de
Londres. Au second plan, la flèche de
l'église St Martin-within-Ludgate,
1906.*

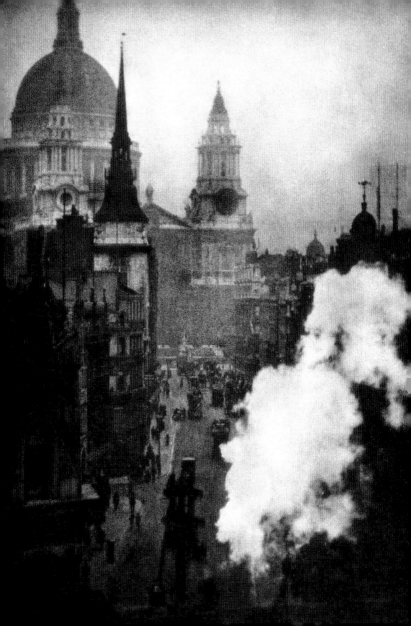

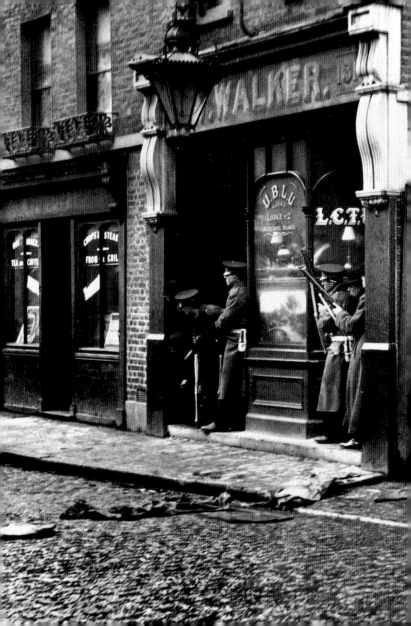

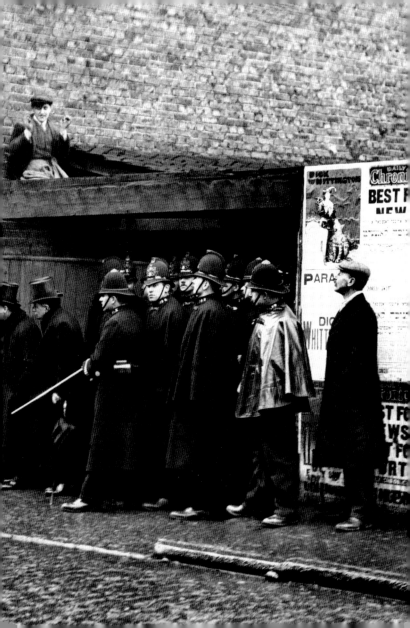

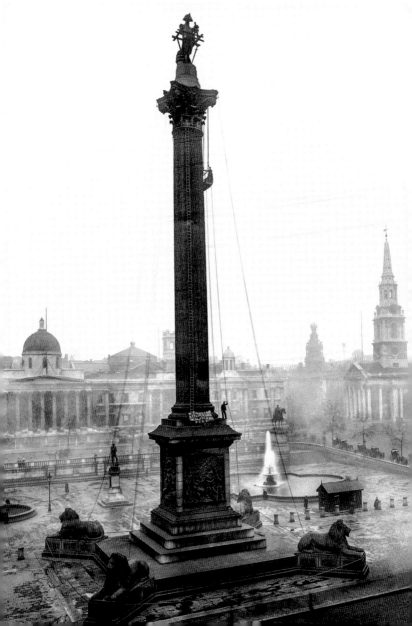

"It was one of those grimy brick houses which existed in large quantities before the era of reconstruction dawned upon London."

„Es war eines der rußigen Backsteinhäuser, wie es sie in großen Mengen gab, bevor in ganz London mit Neubauten begonnen wurde."

« C'était une de ces crasseuses maisons en briques dont on trouvait un grand nombre avant que l'ère de la reconstruction ne se lève sur Londres. »

Joseph Conrad, *The Secret Agent,* **1907**

p. 64/65
Anonymous
The Sidney Street Siege, East London. Winston Churchill, left in top hat, is looking on, 1911.

Die Belagerung der Sidney Street im Osten Londons. Winston Churchill (links, mit Zylinder) sieht zu, 1911.

Le Siège de Sidney Street, dans l'est de Londres. Winston Churchill (à gauche, coiffé d'un haut-de-forme) assiste aux opérations, 1911.

←
Anonymous
Cleaning Edward H. Baily's 17-foot-high (5 m) statue of Horatio Nelson 100 years after his death, Trafalgar Square, 1905.

Reinigung der von Edward H. Baily geschaffenen, gut fünf Meter hohen Statue von Horatio Nelson einhundert Jahre nach dessen Tod, Trafalgar Square, 1905.

Nettoyage de la statue d'Horatio Nelson par Edward H. Baily, haute de plus de 5 m, cent ans après la mort de l'amiral, Trafalgar Square, 1905.

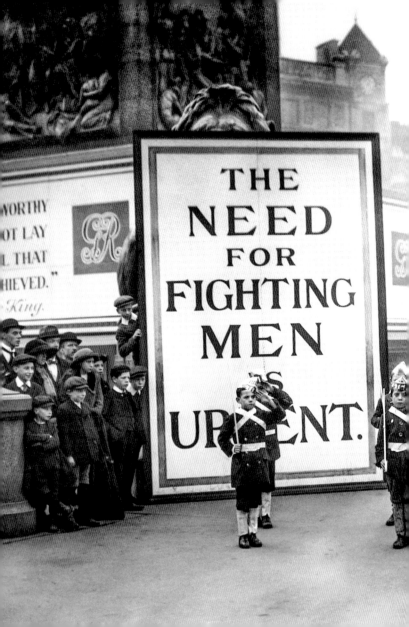

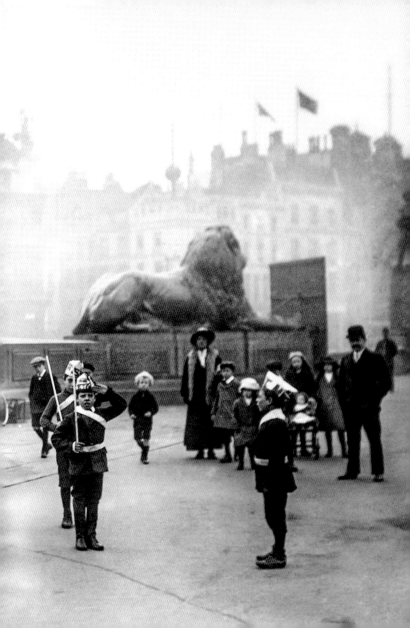

"Masked parties, savage parties, Victorian parties, Greek parties…almost naked parties in St John's Wood…all the succession and repetition of massed humanity…Those vile bodies."

„Maskenfeste, Feste der Wilden, viktorianische Feste, griechische Feste…solche, zu denen man fast nackt kommt, wie in St. John's Wood…dieses ganze endlose Gedränge menschlicher Leiber… diese Anhäufung von Lust und Laster."

« Fêtes masquées, fêtes sauvages, fêtes victoriennes, fêtes grecques…fêtes à demi nus dans le bois de St John's… tout le cortège et la répétition de la masse humaine… ces corps vils. »

Evelyn Waugh, *Vile Bodies*, 1930

Anonymous
Recruitment officers used all means possible to encourage and to shame volunteers into fighting before the Military Service Act of 1916 came into effect, 1914.

Vor Inkrafttreten des Wehrpflichtgesetzes von 1916 versuchten die Werbeoffiziere mit allen Mitteln, mit und ohne Ausübung von Druck, Freiwillige für den Kriegsdienst zu gewinnen, 1914.

Les officiers recruteurs ne reculaient devant aucun moyen, des exhortations à l'humiliation, pour enrôler des volontaires avant l'entrée en vigueur de la loi de conscription, le Military Service Act de 1916, 1914.

→
Anonymous
In London you pay for your taxi ride after you get out, 1929.

In London bezahlt man eine Taxifahrt, wenn man bereits ausgestiegen ist, 1929.

À Londres, le client paie son taxi une fois sorti de voiture, 1929.

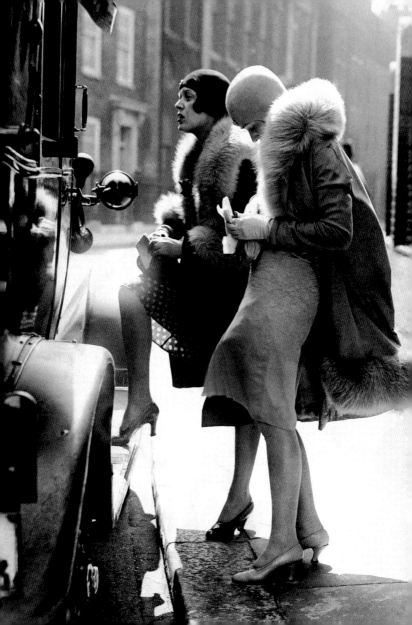

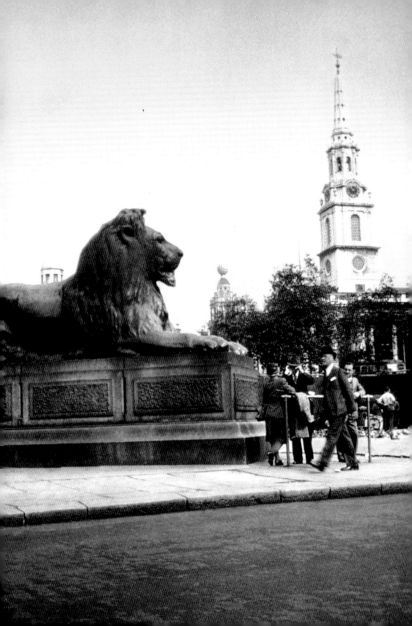

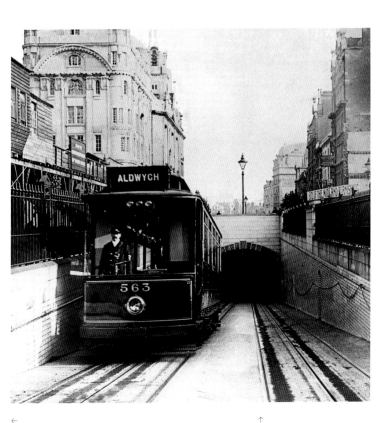

Anonymous

The unchanging prospect of Trafalgar Square: the tower of St Martin-in-the-Fields rises above the trees, with the tower of the London Coliseum behind it. A tourist-friendly lion sits in the foreground, 1930s.

Eine immer gleich bleibende Ansicht von Trafalgar Square: Die Türme von St. Martin-in-the-Fields ragen hinter den Bäumen empor, dahinter sieht man den Turm des London Coliseum. Ein touristenfreundlicher Löwe ist im Vordergrund zu sehen, 1930er-Jahre.

La vue inchangée de Trafalgar Square, avec la tour de l'église St Martin-in-the-Fields dominant les arbres et la tour du London Coliseum à l'arrière-plan. Au premier plan, un lion très prisé des touristes, années 1930.

Anonymous

Tram from Aldwych emerging from the Kingsway Tunnel on the corner of High Holborn, c. 1906.

Straßenbahn aus Aldwych, die an der Ecke der High Holborn aus dem Kingsway-Tunnel auftaucht, um 1906.

Le tramway d'Aldwych sortant du tunnel de Kingsway à l'angle de High Holborn, vers 1906.

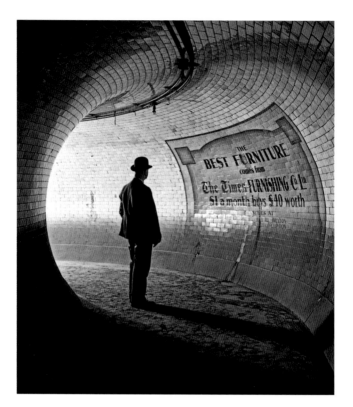

↗

E. O. Hoppé

Holborn station on the Piccadilly and Central lines, showing a rather more permanent form of advertising than the Tube stations of today, 1937.

Diese Anzeige in der Station Holborn der Piccadilly und der Central Line ist langlebiger als die Werbung in den heutigen U-Bahn-Stationen, 1937.

La station Holborn, à l'intersection de la Piccadilly Line et de la Central Line, présente une forme de publicité plus permanente que celle des stations de métro d'aujourd'hui, 1937.

→

E. O. Hoppé

A civil servant negotiates the stairs at Westminster Tube station, 1937.

Ein Staatsdiener steigt die Treppen zur U-Bahn-Station Westminster hinunter, 1937.

Un fonctionnaire s'apprête à descendre les escaliers de la station de métro Westminster, 1937.

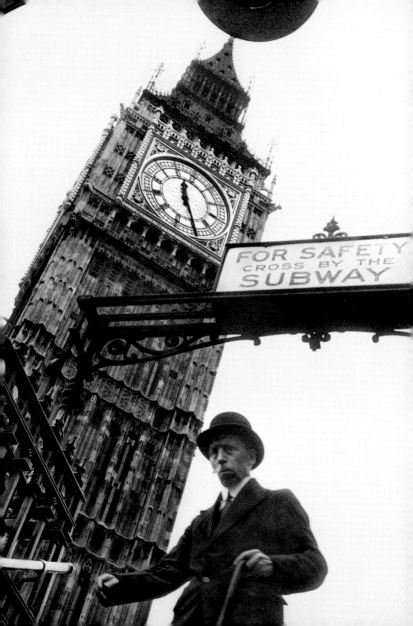

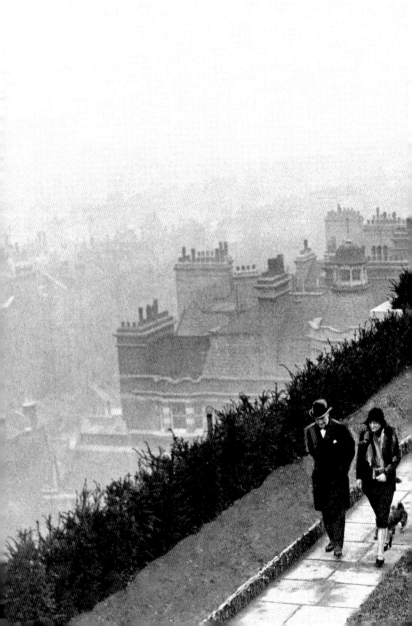

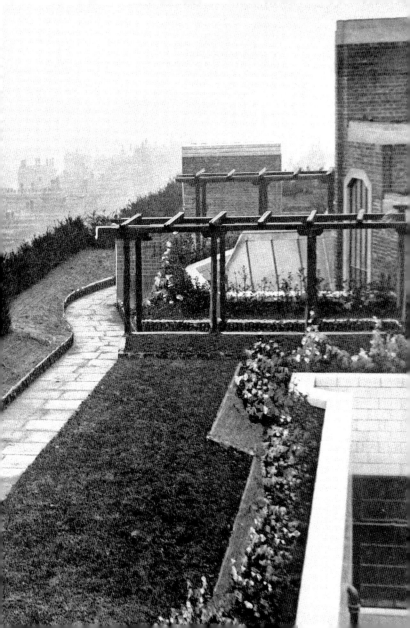

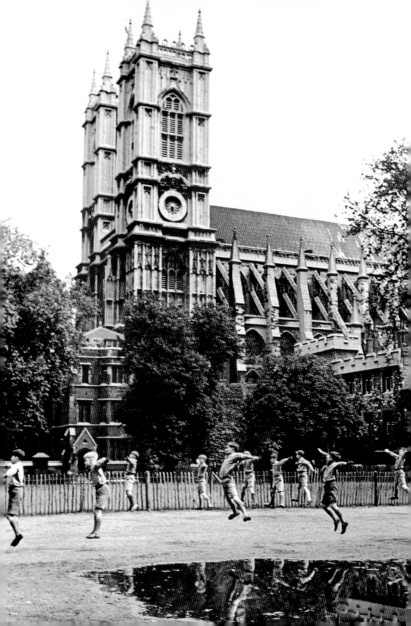

"Never had he seen London look so enchanting
– the softness of the distances, the richness, the
greenness, the civilization."

„Nie war ihm London so bezaubernd erschienen
– die Weichheit der Perspektiven, die Gediegen-
heit, das Grün, die Zivilisation."

« Jamais Londres n'avait eu un air aussi enchan-
teur – la douceur des distances, la richesse, la
verdure, la civilisation. »

Virginia Woolf, *Mrs. Dalloway*, 1925

p. 76/77
Anonymous
*Luxury living: the roof garden of
Berkeley Court, at the Regent's Park
end of Baker Street, one of the new
Continental-style luxury apartment
blocks being built in London in
the 1930s, 1931.*

*Leben im Luxus in der Baker Street
am Regent's Park: Dachgarten
von Berkeley Court, einem der
neuen Luxusapartmenthäuser
im kontinentalen Stil, die in den
1930er-Jahren in London erbaut
wurden, 1931.*

*Une vie de luxe : le jardin-terrasse
de Berkeley Court, à l'extrémité de
Baker Street, côté Regent's Park,
fait partie d'un des nouveaux blocs
d'immeubles de standing de style
continental construits à Londres dans
les années 1930, 1931.*

←
Anonymous
*Boys at Westminster School getting a
physical education lesson, 1930.*

*Schüler der Westminster School beim
Sportunterricht, 1930.*

*À Westminster School, des écoliers en
cours d'éducation physique, 1930.*

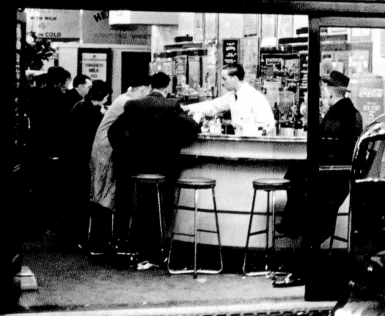

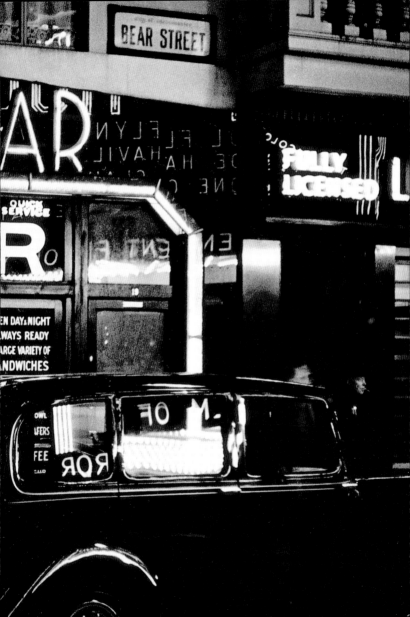

MEAT
3 HALF
CAT & DOGS ME.
Fresh Daily.

ESTABLISHED OVER 50 YEARS.

CATS
MEAT
3

CAT & DOG
Powders

CAT
ME
3

"In the Charing Cross Road the tea-shops called like sirens. Once the glass door of a Lyons swung open, letting out a wave of hot cake-scented air. It almost overcame him."

„In der Charing Cross Road lockten die Teestuben wie Sirenen. Einmal schwang die Glastür eines Lyons auf und ließ einen Schwall heißer, kuchen-duftgeschwängerter Luft nach draußen. Es über-wältigte ihn fast."

« Dans Charing Cross Road, les salons de thé exerçaient l'attrait des sirènes. Une fois, la porte vitrée d'un Lyons s'ouvrit avec une bouffée d'air chargée des senteurs de gâteaux chauds. Il en fut presque submergé. »

George Orwell, *Keep the Aspidistra Flying,* **1936**

p. 80/81
Anonymous
The 24-hour Milk Bar on Bear Street, just off Leicester Square in Soho, c. 1936.

Die rund um die Uhr geöffnete Milchbar in der Bear Street nahe dem Leicester Square in Soho, um 1936.

Le Milk Bar ouvert 24 h/24 dans Bear Street, juste à côté de Leicester Square, à Soho, vers 1936.

←
Wolf Suschitzky
Offcuts and offal, sold as cat and dog food, were often the only meat that poor people could afford, Paddington, 1935.

Fleischabfälle und Innereien, die als Katzen- und Hundefutter verkauft wurden, waren häufig das einzige Fleisch, das sich die arme Bevölke-rung leisten konnte, Paddington, 1935.

Vendus comme nourriture pour chats et chiens, les chutes et les déchets étaient souvent la seule viande que pouvaient acheter les pauvres, Paddington, 1935.

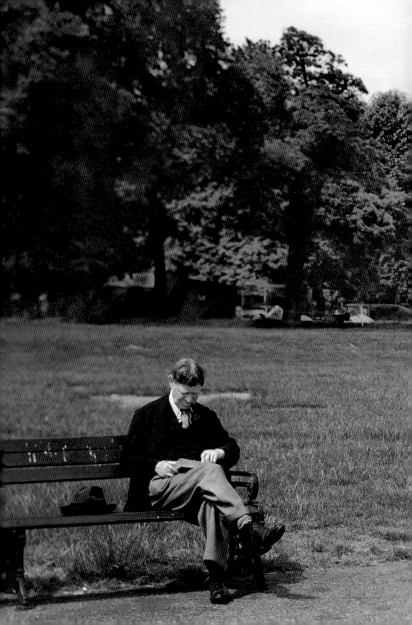

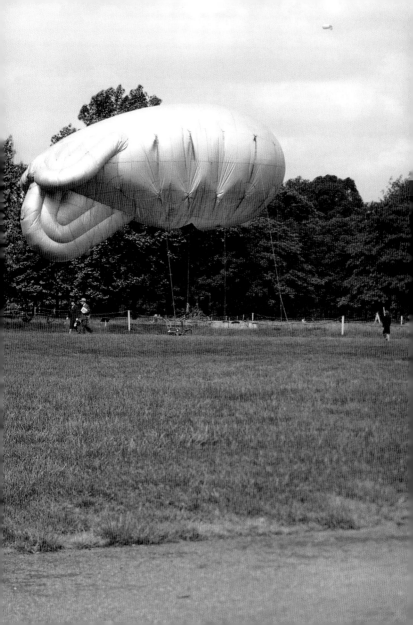

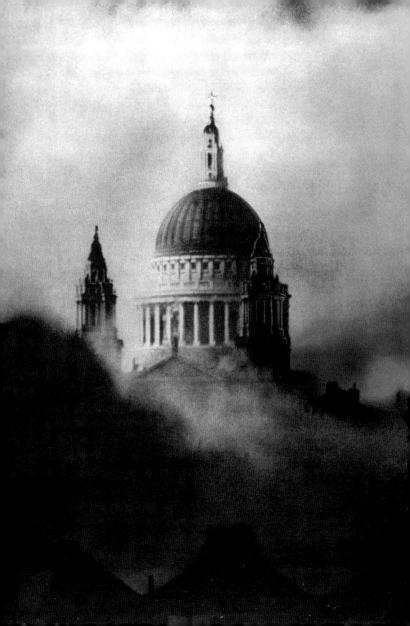

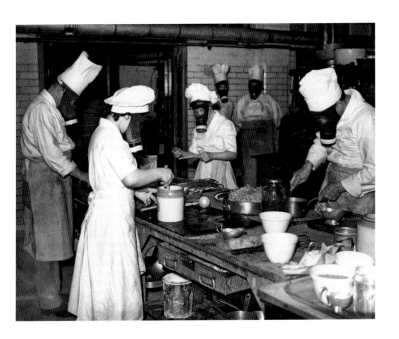

p. 84/85
William Vandivert
By 1940 London had more than 500 barrage balloons to guard against low-level dive-bomb attacks, 1941.

1940 gab es in London über 500 Sperrballons zum Schutz gegen niedrig fliegende Bomber, 1941.

En 1940, Londres possédait plus de 500 ballons de barrage pour se défendre contre les attaques en rase-mottes ou en piqué, 1941.

←
Herbert Mason
St Paul's Cathedral during the so-called Second Great Fire of London, on the night of 29–30 December 1940.

Die St. Paul's Cathedral beim sogenannten zweiten Großen Brand von London in der Nacht vom 29. auf den 30. Dezember 1940.

La cathédrale Saint-Paul pendant la nuit du 29 au 30 décembre 1940, connue comme le « Second Grand Incendie de Londres ».

↑
Anonymous
London's great hotels attempted to carry on as usual, Grosvenor Hotel, 1940.

In den großen Londoner Hotels versuchte man, ganz normal weiterzuarbeiten, Grosvenor Hotel, 1940.

Les grands hôtels de Londres tentèrent de poursuivre leurs activités comme à l'accoutumée, Grosvenor Hotel, 1940.

"*Things blew up and things blew down*
Seemed a blinkin' shame!
Bloomin' fire and flame!
Blimey – what a game!
But who stayed up and saved the town
When London Bridge was falling down
Mister Brown of London Town
Oi!! Mister Brown!"

Reginald Arkell & Noel Gay
"Mister Brown of London Town", 1941

→
John Hinde
In what looks like a staged morale-boosting image, a woman saves a board game from the bomb wreckage, c. 1939–1945.

Auf diesem gestellt wirkenden Bild, mit dem die Bevölkerung aufgemuntert werden sollte, rettet eine Frau ein Brettspiel aus den Bombentrümmern, zwischen 1939 und 1945.

Dans cette photo qui a tout l'air d'une mise en scène destinée à soutenir le moral de la population, une femme sauve un jeu de société des décombres, vers 1939–1945.

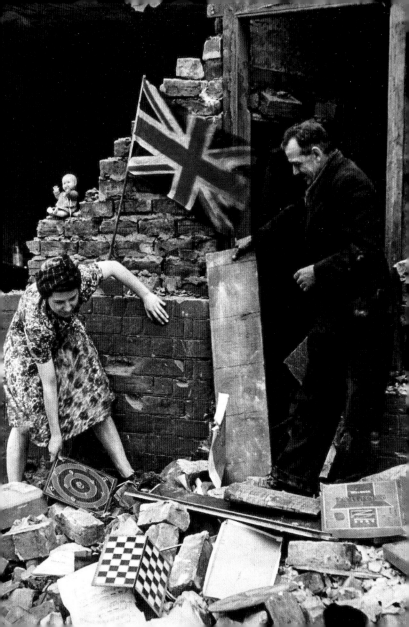

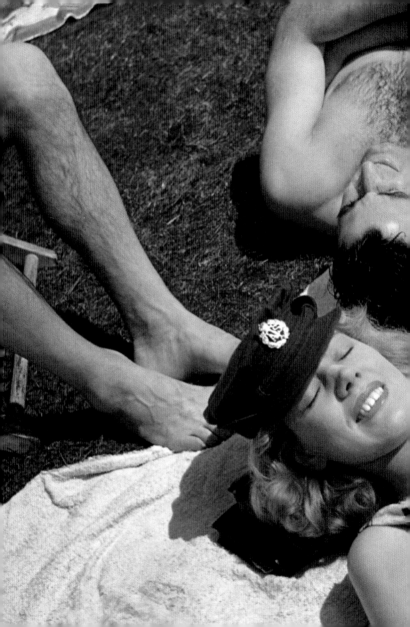

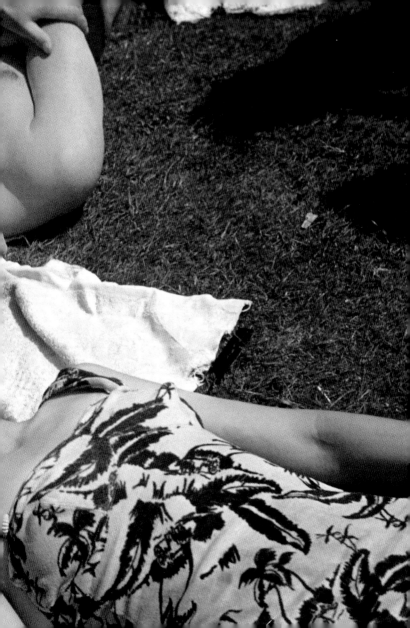

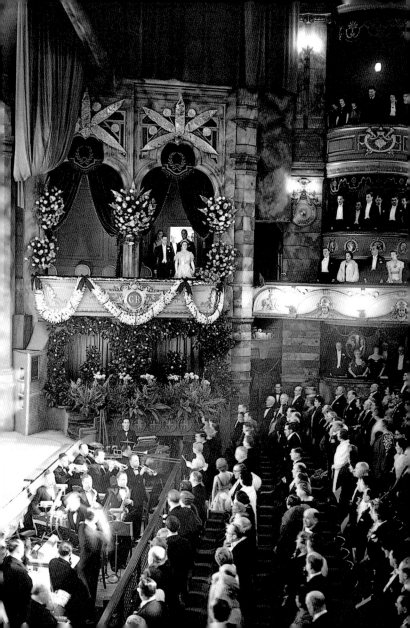

"Lambeth you've never seen,
The skies ain't blue, the grass ain't green.
It hasn't got the Mayfair touch,
But that don't matter very much.
We play the Lambeth way."

"The Lambeth Walk", from the musical
***Me and My Girl*, 1937**

p. 90/91
Anonymous
The first week of June 1942 was
hotter than usual, reaching 29.4
degrees Celsius on the 6th. Londoners
took advantage of the heat to
sunbathe in the parks, 1942.

In der ersten Juniwoche des Jahres
1942 war es wärmer als gewöhnlich;
am 6. Juni erreichten die Temperatu-
ren 29,4 Grad Celsius. Die Londoner
genossen die Hitze und nahmen ein
Sonnenbad im Park, 1942.

Pendant la première semaine de
juin 1942, les températures (29,4 °C
le 6 juin) furent plus élevées que
d'autres années. Les Londoniens
profitèrent de la chaleur pour prendre
des bains de soleil dans les parcs,
1942.

←
Anonymous
King George VI and Queen Elizabeth
attend a royal command performance
at the London Coliseum, 1938.

König George VI. und Königin
Elizabeth besuchen im London
Coliseum eine Hofsondervorstellung,
1938.

Au London Coliseum, le roi George
VI et la reine Elisabeth assistant à
une représentation commandée par
le couple royal, 1938.

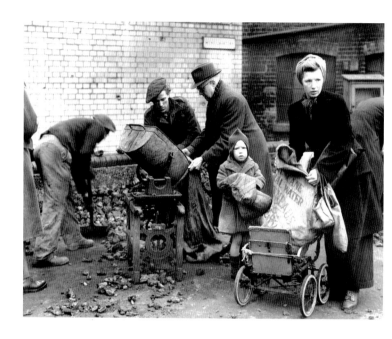

Anonymous

*Coal was delivered in hundredweight
(50 kg) sacks but many people didn't
trust the coal-men and preferred
to buy it loose and see it weighed out
for themselves as at this coal yard
in Vauxhall, 1947.*

*Kohle wurde in 50-Kilo-Säcken
angeliefert, aber viele trauten den
Kohlenmännern nicht über den Weg
und kauften sie lieber lose; sie sahen
dabei zu, wie die Kohle gewogen
wurde, beispielsweise auf diesem
Kohlenplatz in Vauxhall, 1947.*

*Le charbon était livré en sacs de
50 kg, mais bien des gens ne se fiaient
pas aux charbonniers et préféraient
acheter leur charbon au détail, pesé
sous leurs propres yeux comme sur ce
dépôt de charbon de Vauxhall, 1947.*

→
B. Anthony Stewart

*Preparing to fly the Union Jack
from Victoria Tower of the Palace
of Westminster, 1946.*

*Auf dem Victoria Tower des Palace
of Westminster werden die Vorberei-
tungen getroffen, um den Union
Jack zu hissen, 1946.*

*L'Union Jack prêt à être hissé
sur la tour Victoria du palais de
Westminster, 1946.*

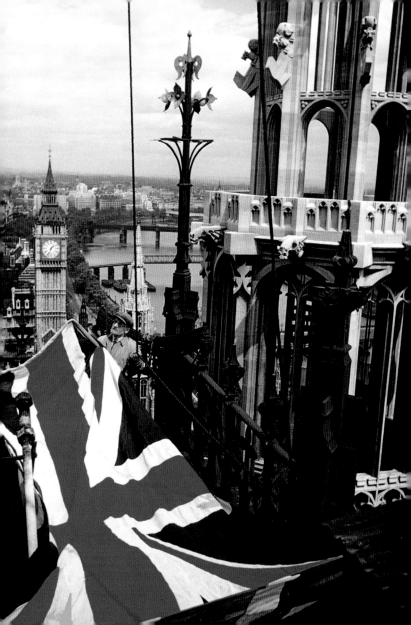

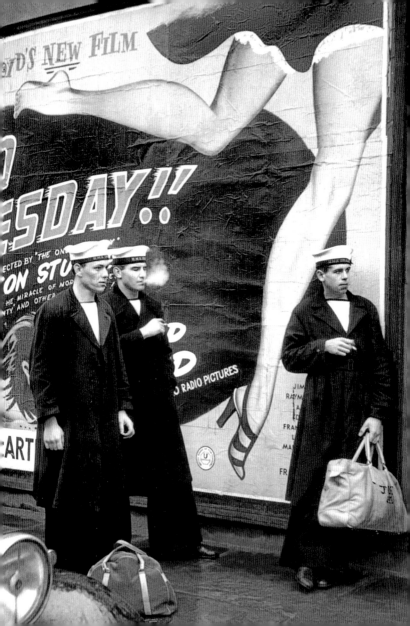

←
Thurston Hopkins

*Sailors on leave looking for a good
time in London's West End, 1951.*

*Matrosen auf Landgang wollen sich
im Londoner West End amüsieren,
1951.*

*Des marins en partance cherchent
à passer un peu de bon temps dans
le West End de Londres, 1951.*

↑
Bill Brandt

*Charlie Brown's pub at 114–116
West India Dock Road, in Limehouse,
was the most famous pub in London
before the war, 1945.*

*Charlie Brown's Pub, 114–116 West
India Dock Road in Limehouse,
war vor dem Krieg der berühmteste
Pub in London, 1945.*

*Le Charlie Brown's Pub, au 114–116
West India Dock Road, à Limehouse,
était le pub le plus célèbre de la
Londres d'avant-guerre, 1945.*

p. 98/99
Anonymous

*The opening ceremony of the London
Olympics, 1948.*

*Die Eröffnungsfeier der Olympischen
Spiele in London, 1948.*

*La cérémonie d'ouverture des Jeux
olympiques de Londres, 1948.*

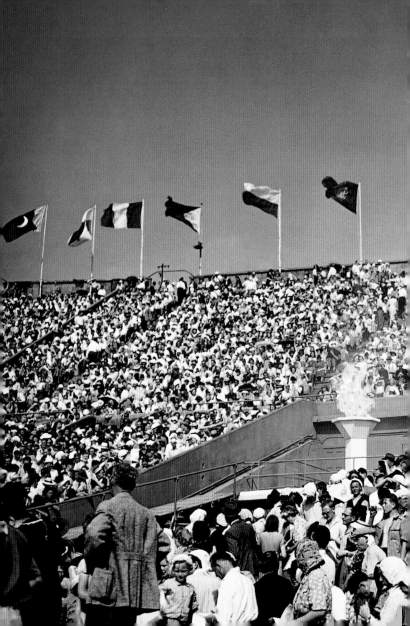

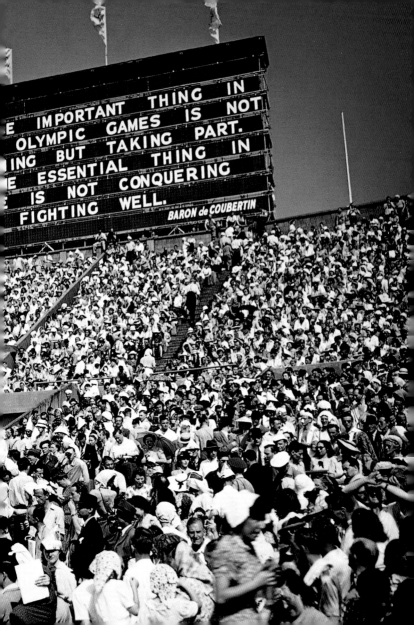

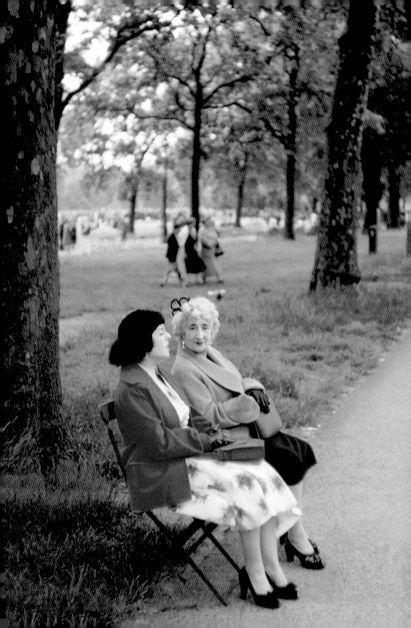

"One-Round, there is a wheelbarrow outside, could you fetch it? The Major has a train to catch."

„One-Round, hol die Schubkarre von draußen. Der Major muss nämlich einen Zug kriegen."

« One-Round, y'a une brouette dehors, tu peux la récupérer? Le major a un train à prendre. »

The Ladykillers, 1955

←
Frank Horvat
Hyde Park is the largest park in central London, covering 625 acres (253 ha), including the adjacent Kensington Gardens, 1955.

Der Hyde Park ist der größte Park im Zentrum von London; zusammen mit den angrenzenden Kensington Gardens nimmt er eine Fläche von 253 Hektar ein, 1955.

Avec une superficie de 253 ha en comptant les jardins de Kensington, Hyde Park est le plus grand espace vert du centre de Londres, 1955.

p. 102/103
Elmar Ludwig
Battersea Fun Fair, opened in 1951, was part of the Festival of Britain celebrations, 1951.

Der Vergnügungspark Battersea Fun Fair öffnete 1951 als Teil des Festival of Britain seine Pforten, 1951.

La Fun Fair à Battersea ouvrit ses portes en 1951; la foire faisait partie des célébrations du Festival of Britain, 1951.

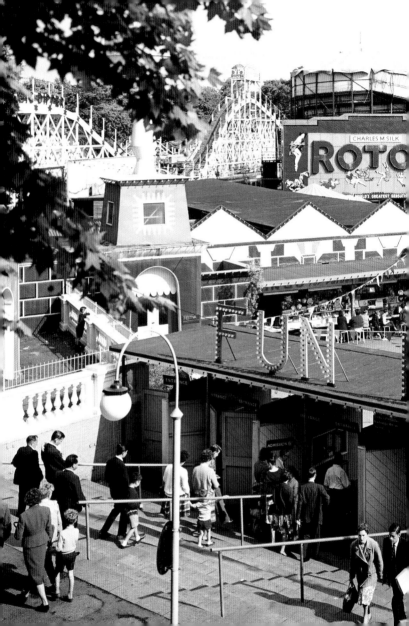

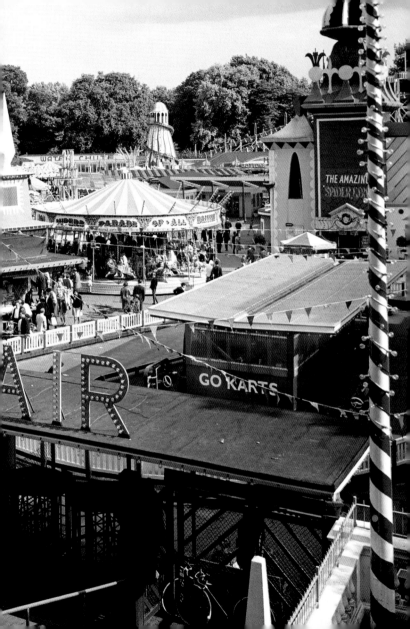

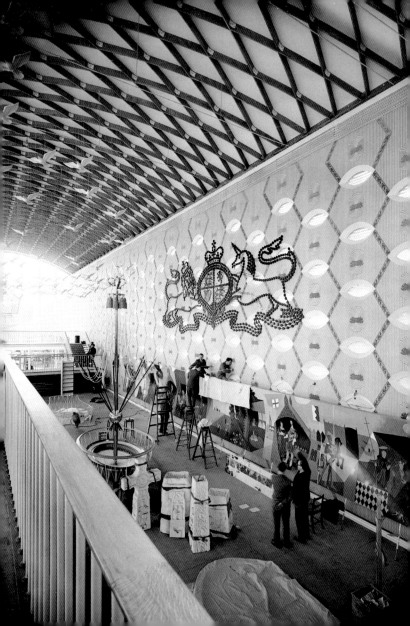

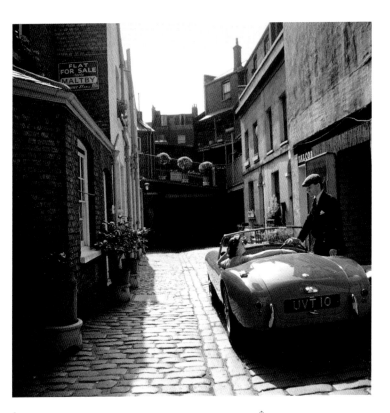

←
Norman Vigars

The Lion and the Unicorn pavilion in the 'Dome of Discovery' at the Festival of Britain, a superb example of 1950s kitsch. Had it survived, the lighting unit would now be in a museum, 1951.

Der „The Lion and the Unicorn"-Pavillon beim Festival of Britain, ein wunderbares Beispiel für den „Kitsch" der 1950er-Jahre. Wäre sie noch erhalten, stünde diese Beleuchtungs-anlage heute sicherlich im Museum, 1951.

Le Lion and the Unicorn pavilion (le pavillon du lion et de la licorne) au Festival of Britain est un splendide exemple du kitsch des années 1950. S'il avait survécu, le lampadaire serait aujourd'hui dans un musée, 1951.

↑
Slim Aarons

A proud couple showing off their new two-seater AC Ace sports car, introduced in 1953, in a London mews, 1955.

Ein Pärchen zeigt in den London Mews voller Stolz seinen neuen zweisitzigen AC Ace-Sportwagen, der 1953 auf den Markt kam, 1955.

Dans une petite rue de Londres, un couple exhibe fièrement sa nouvelle voiture de sport deux places d'AC Ace, modèle 1953, 1955.

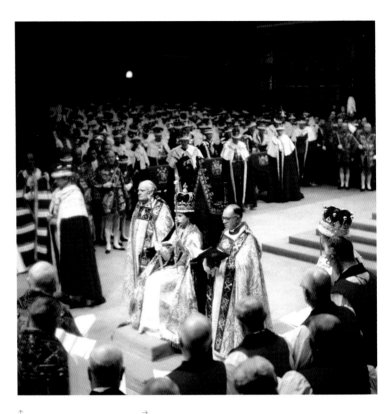

↑
Anonymous
*Coronation of Queen Elizabeth II at
Westminster Abbey, 1953.*

*Die Krönung von Königin Elizabeth
II. in der Westminster Abbey, 1953.*

*Le couronnement d'Élisabeth II à
l'abbaye de Westminster, 1953.*

→
Werner Bischof
*The year 1953 had the worst
June weather of the 20th century.
Spectators at the coronation of
Queen Elizabeth II arrived well
prepared, 1953.*

*1953 war das Wetter im Juni ganz
besonders schlecht. Die Zuschauer der
Krönung von Königin Elizabeth II.
hatten sich gut darauf vorbereitet,
1953.*

*La météorologie du mois de juin
1953 fut la pire du siècle. Les specta-
teurs venus assister au couronnement
de la reine Élisabeth II étaient vêtus
en conséquence, 1953.*

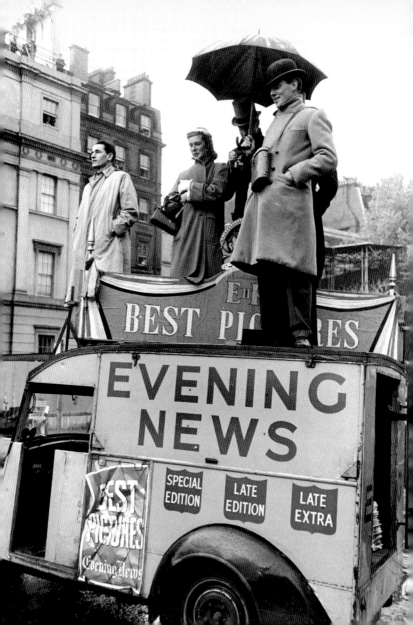

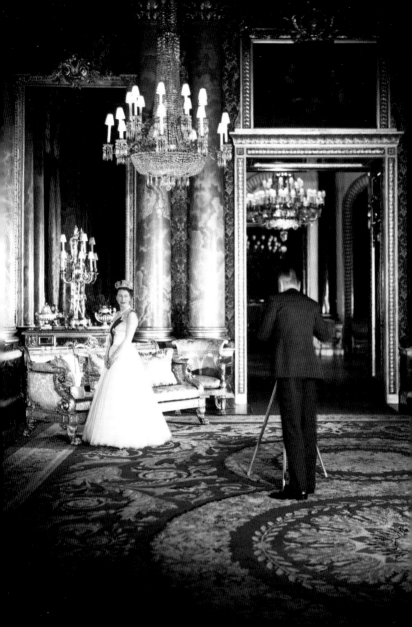

"Two happy young people whose story has captured the imagination of the world."

„Zwei glückliche junge Menschen, deren Geschichte die Fantasie der ganzen Welt beflügelt hat."

« Deux jeunes gens heureux dont l'histoire a captivé l'imagination du monde.»

Independent Television News Report, 1947

←
Anonymous
Cecil Beaton photographing Queen Elizabeth II, wearing the Order of the Garter, at Buckingham Palace, 1953.

Cecil Beaton fotografiert Königin Elizabeth II., Trägerin des Hosenbandordens, im Buckingham Palace, 1953.

Au palais de Buckingham, Cecil Beaton photographie la reine Élisabeth II portant l'ordre de la Jarretière, 1953.

p. 110/111
Inge Morath
A corner shop in Chelsea. These Regency terraces are now among the most fashionable in the country, 1955.

Tante-Emma-Laden in Chelsea. Die hier gezeigten Regency Terraces gehören heute zu den schicksten Gebäuden des Landes, 1955.

Un magasin de quartier à Chelsea. Les Regency Terraces (à droite) comptent aujourd'hui parmi les immeubles les plus chics du pays, 1955.

Craven 'A'
NEVER VARY

Ogden's St. BRUNO
is finest tobacco!

Ogden's
St. JULIEN
Cool & Fragrant!

COACHMAN

CROWN GOLD

Player's Please

PLAYER'S

DIGGER

JOHN BULL

NEW
OF THE
WOR

COACHMAN

TOP NOTE

THE FAMILY
MAGAZINE
OF GOOD
READING

EVERY WEDNESDAY

DBINE''

TTES

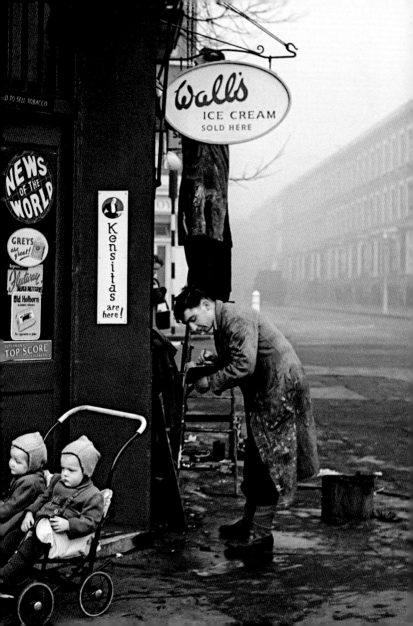

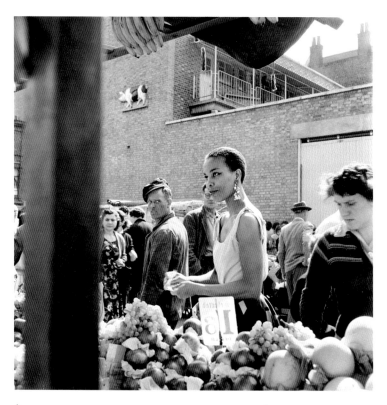

↑
John Gay
A young woman draws stares in
a North London street market,
1946–1955.

Eine junge Frau zieht auf einem
Markt in North London alle Blicke
auf sich, 1946–1955.

Une jeune femme attire les regards
des passants sur un marché de rue
du nord de Londres, 1946–1955.

→
Roger Mayne
A young couple turn the corner of
a grubby Kensington backyard into
a summer beach, 1958.

Ein junges Pärchen verwandelt die
Ecke eines schäbigen Hinterhofes in
Kensington in einen Sommerstrand,
1958.

Un jeune couple transforme une
sordide arrière-cour de Kensington
en plage estivale, 1958.

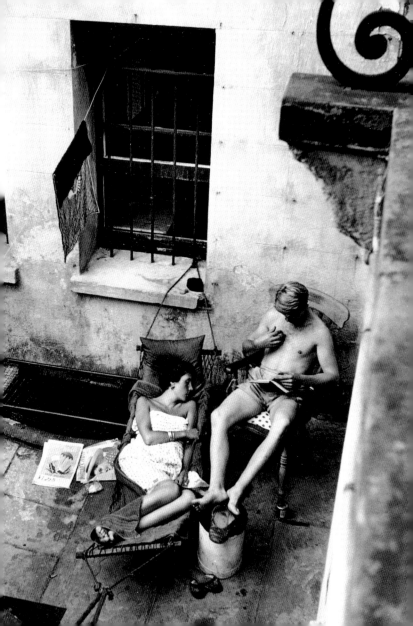

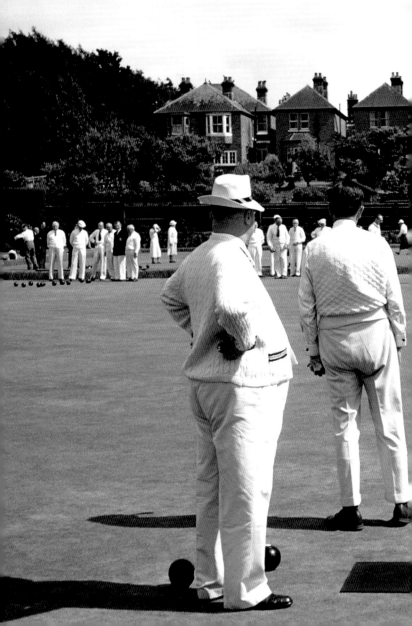

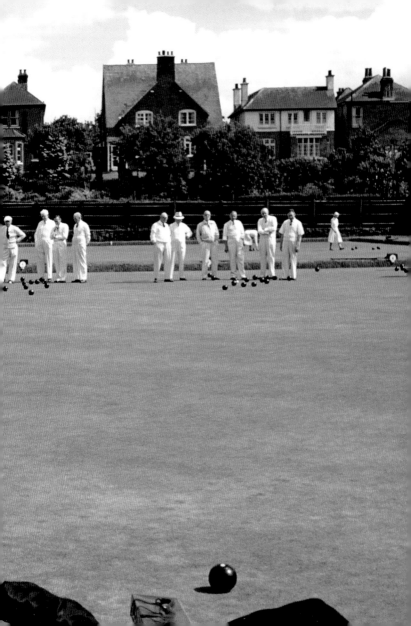

*"Hip Hurrah! Hip Hooray!
Biffo Bear is here today!"*

*„Hipp hipp hurra! Hipp hipp hurra!
Der Biffo-Bär ist wieder da!"*

*« Hip-hip-hip, hourrah !
Biffo l'ours est là ! »*

The Beano, 1948

p. 114/115
Slim Aarons
*A bowling green in the London
suburbs. Bowling has always been
a highly competitive sport for ladies
and gentlemen of a certain age,
1955.*

*Ein Bowling Green in einem Vor-
ort von London. Rasen-Bowling
war bei Damen und Herren eines
gewissen Alters schon immer als
Wettkampfsport beliebt, 1955.*

*Terrain de bowling dans la banlieue
de Londres. Le bowling a toujours
été un sport hautement compétitif
pour les dames et les messieurs d'un
certain âge, 1955.*

→
Roger Mayne
*Kensington schoolboys using cigarettes
to look tough. Note their attempts at
a 'Teddy Boy' haircut, 1958.*

*Schüler aus Kensington rauchen
Zigaretten, um wie harte Jungs zu
wirken. Man beachte ihre Frisuren,
die an die Mode der Teds erinnern,
1958.*

*Des écoliers de Kensington fument
pour se donner des airs d'hommes.
Considérez leur coupe de cheveux
proche de celle des Teddy Boys, 1958.*

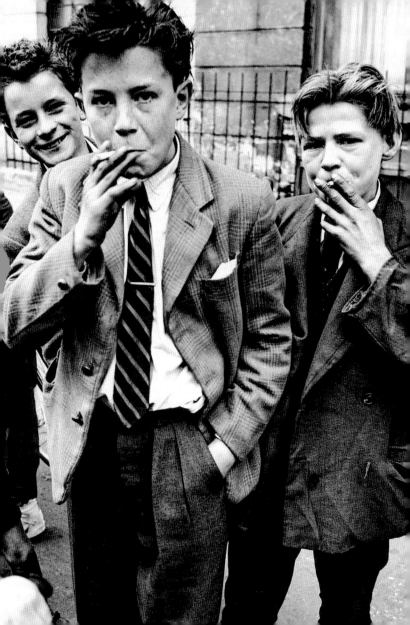

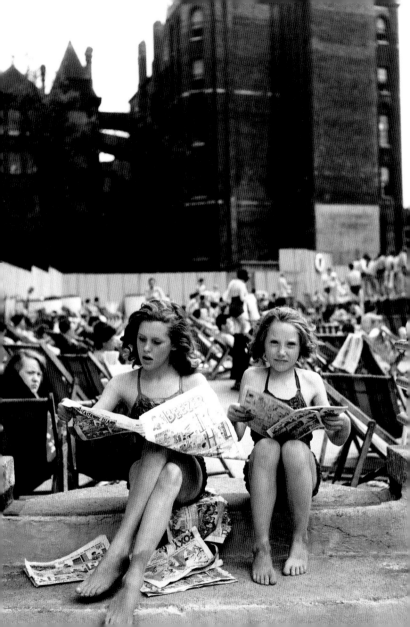

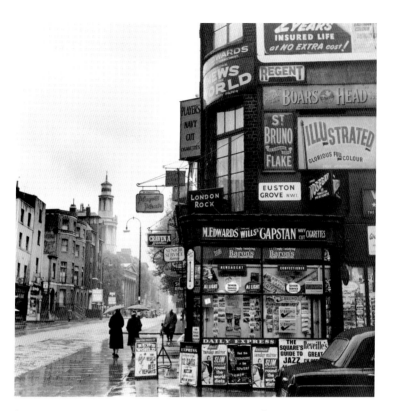

← **Anonymous**

Children sunbathing next to the old outdoor rooftop swimming pool at the Oasis Leisure Centre, Covent Garden, 1956.

Des enfants prennent un bain de soleil autour de l'ancienne piscine à ciel ouvert située sur la terrasse de l'Oasis Leisure Centre, Covent Garden, 1956.

Kinder beim Sonnenbaden im alten Freibad auf dem Dach des Oasis Leisure Centre, Covent Garden, 1956.

↑ **Antony Armstrong-Jones**

An evocative view of a newsagent on the corner of Euston Road and Euston Grove, 1957.

Ein atmosphärisches Bild des Zeitschriftenhändlers an der Ecke Euston Road und Euston Grove, 1957.

Vue évocatrice d'un commerçant de presse à l'angle d'Euston Road et d'Euston Grove, 1957.

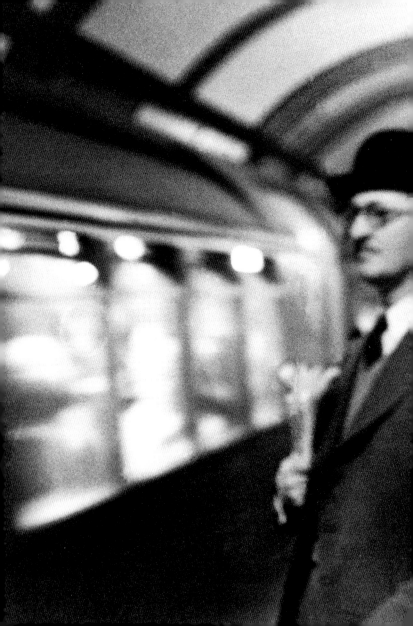

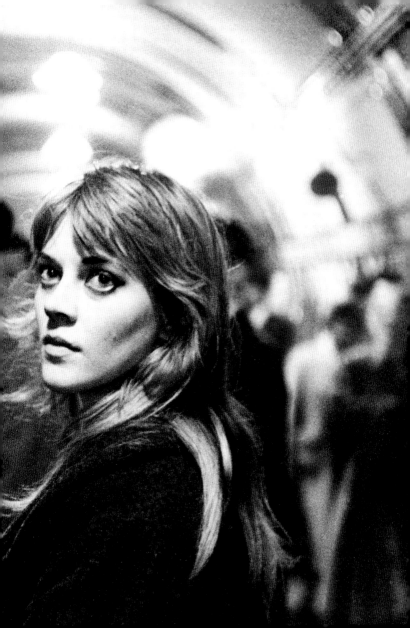

"My understanding of women only goes as far as the pleasure. When it comes to the pain I'm like any other bloke – I don't want to know."

„Mein Interesse für Frauen geht nur so weit, wie es Spaß macht. Aber wird der Spaß ernst, bin ich so wie alle Männer – ich will nichts davon wissen."

« Ma compréhension des femmes ne va pas au-delà du plaisir. Quand on en arrive à la souffrance, je suis comme n'importe quel autre mec – ça ne m'intéresse pas. »

Alfie, 1966

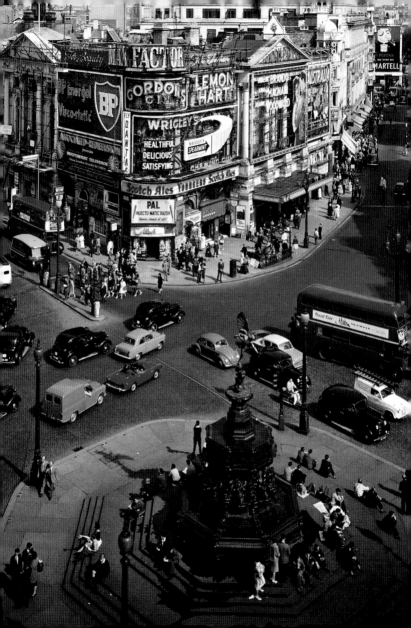

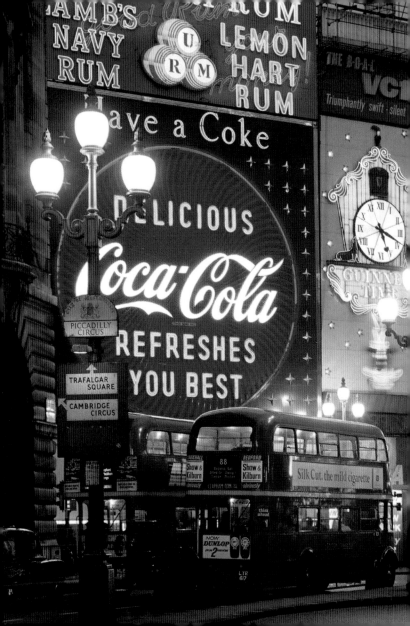

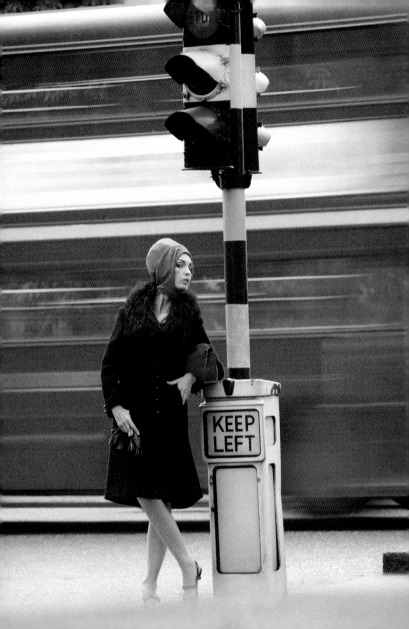

"I'm an honest working girl."
"Five bob in the Walworth Road.
 That's about your bloody mark."

„Ich bin ein ehrbares Mädchen."
„Fünf Pfund in der Walworth Road.
 Hier, das schulde ich Dir."

« Je suis une honnête fille. »
« Cinq livres dans Walworth Road.
 Voilà tout ce que tu vaux. »

***Darling*, 1965**

←
Norman Parkinson
*A Queen magazine fashion shot:
the red bus echoes the red traffic light
and the model's accessories. The
cool model creates an iconic image
of what would become 'Swinging
London', 1960.*

*Eine Modeaufnahme in der Zeit-
schrift Queen: Der rote Bus greift das
Rot der Ampel und der modischen
Accessoires des Fotomodells auf. Der
coole Look des Mannequins steht
sinnbildlich für das spätere „Swin-
ging London", 1960.*

*Photo de mode publiée dans le
magazine Queen : le bus rouge fait
écho au feu rouge et aux accessoires
de mode du modèle. Le top model
décontracté a créé une image iconique
de ce qui allait devenir la Swinging
London, 1960.*

p. 128/129
Anonymous
*Passengers and poster advertisements
on a railway platform, 1965.*

*Passagiere und Werbeplakate auf
einem Bahnsteig, 1965.*

*Voyageurs et affiches publicitaires sur
un quai ferroviaire, 1965.*

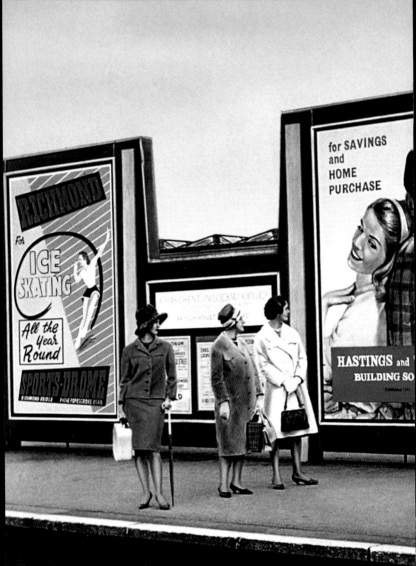

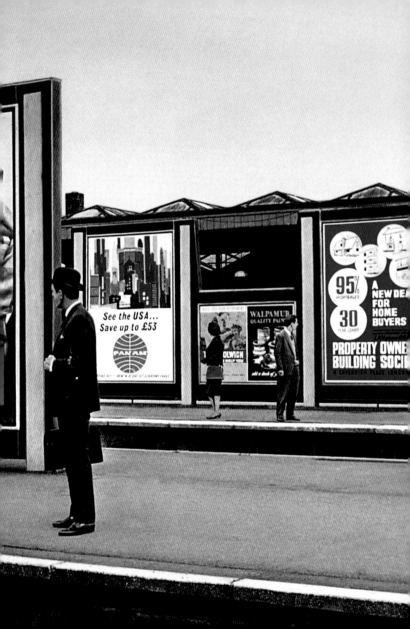

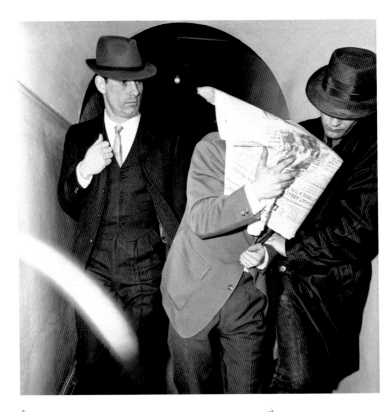

↑
Terence Donovan
Donovan, from Mile End Road in the East End, used the public's fascination with celebrity gangsters like the Kray twins to create this fashion shot, 1961.

Donovan, der in der Mile End Road im East End aufwuchs, machte sich bei seinen Modeaufnahmen die Faszination der Öffentlichkeit für prominente Kriminelle wie die Kray-Zwillinge zunutze, 1961.

Pour cette photo de mode, Donovan, qui passa son enfance dans les quartiers de Mile End Road, dans l'East End, a exploité la fascination du public pour les célébrités du milieu comme les frères Kray, 1961.

→
Larry Fink
Relaxing with a fag, c. 1966.

Zigarettenpause, um 1966.

Moment de détente avec une clope, vers 1966.

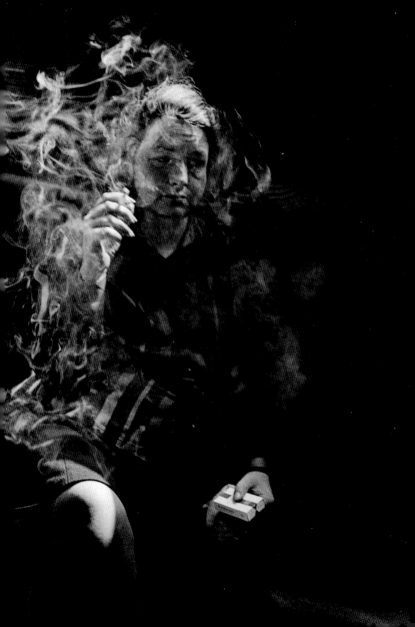

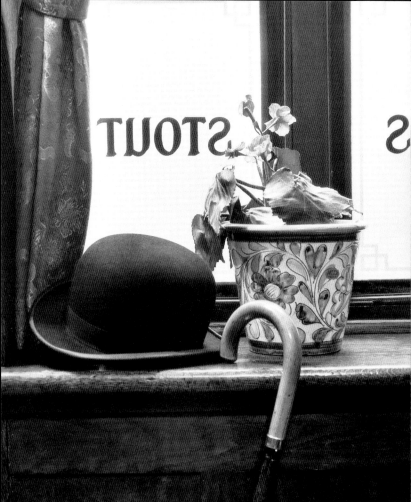

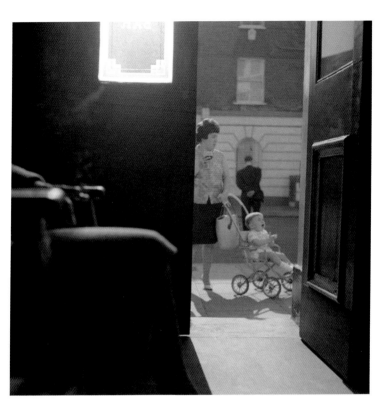

←

Evelyn Hofer

Still life in the saloon bar, an

illustration from London Perceived

by V. S. Pritchett, 1962.

Stillleben in einer Saloon Bar;

Fotografie aus London Perceived

von V. S. Pritchett, 1962.

Nature morte au saloon bar.

Photographie du livre de V. S.

Pritchett London Perceived, *1962.*

↑

Paul Styles

Inside and outside the Warwick

Castle pub on Shirland Road,

Maida Vale, 1960.

Der Schankraum und die Straße vor

dem Warwick Castle Pub auf der

Shirland Road, Maida Vale, 1960.

L'intérieur et l'extérieur du pub

Warwick Castle, sur Shirland Road,

Maida Vale, 1960.

p. 134/135

Edward Miller

Fog makes the departure board

at London's Liverpool Street station

hard to read, 1959.

Im dichten Londoner Nebel ist die

Fahrplantafel im Bahnhof Liverpool

Street kaum zu erkennen, 1959.

La brume ne facilite pas la lecture

du tableau d'affichage des départs de

la gare de Liverpool Street, 1959.

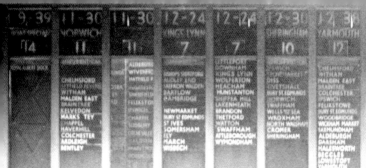

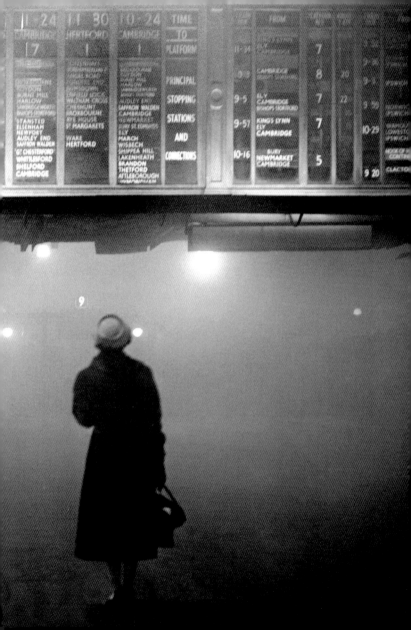

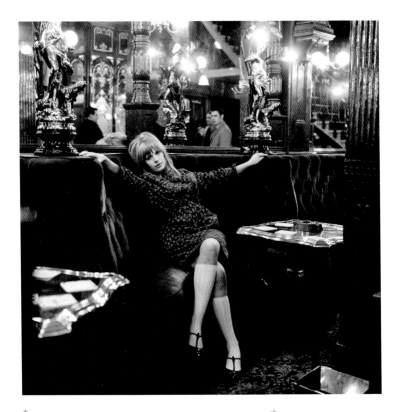

↑
Gered Mankowitz

Eighteen-year-old Marianne Faithfull poses for a sleeve shot for her 1965 debut album, Come My Way, *in the Salisbury Arms pub in St Martin's Lane on the edge of Soho, 1965.*

Die 18-jährige Marianne Faithfull posiert im Salisbury Arms Pub in der St. Martin's Lane am Rande von Soho für die Plattenhülle ihres Debütalbums Come My Way *aus dem Jahr 1965.*

Marianne Faithfull âgée de 18 ans pose pour la pochette de son premier album Come My Way *(1965) au Salisbury Arms Pub, dans St Martin's Lane, à la limite de Soho, 1965.*

→
Evelyn Hofer

At the Chelsea Flower Show, an immaculately turned out city gent studies the carefully arranged blooms, 1962.

Auf der Chelsea Flower Show studiert ein makellos gekleideter Herr aus der City die sorgsam arrangierte Blütenpracht, 1962.

Un monsieur impeccablement vêtu de la City étudie des bouquets soigneusement arrangés à l'exposition florale de Chelsea, 1962.

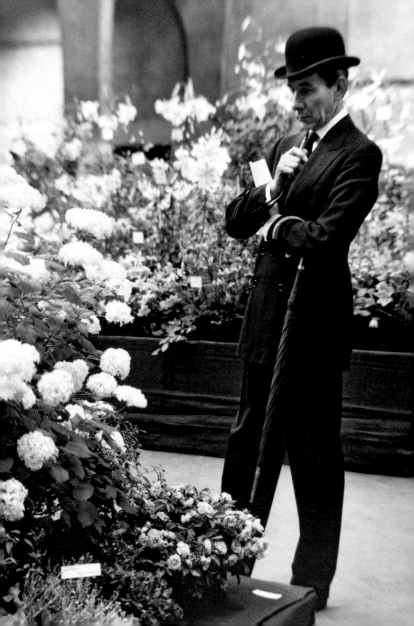

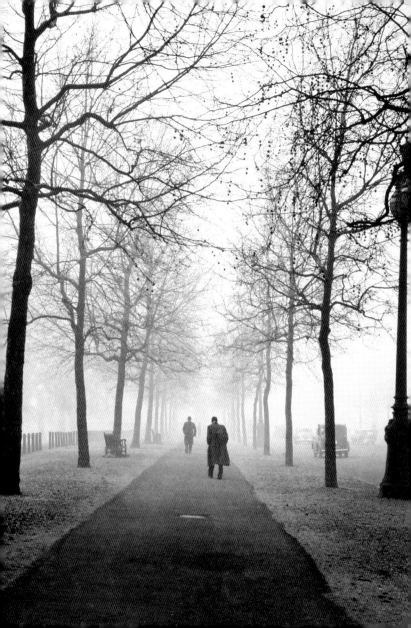

"*Do you know what she's done now? Gone off with my money and living with a bookie in Wandsworth. Wandsworth!*"

„*Weißt du, was sie gemacht hat? Sie ist mit meinem Geld auf und davon und lebt jetzt mit einem Buchmacher in Wandsworth. Wandsworth!*"

« *Tu sais ce qu'elle vient de faire? Partie avec le fric pour vivre avec un bookmaker à Wandsworth. Wandsworth!* »

The Servant, 1963

←

Evelyn Hofer

A quintessential London winter scene, with pedestrians strolling down the Mall towards Buckingham Palace, which remains hidden from view by the mist, 1962.

Der Inbegriff einer Londoner Winterszene: Fußgänger spazieren die Mall hinunter in Richtung Buckingham Palace, der im dichten Nebel nicht zu erkennen ist, 1962.

Scène d'hiver londonienne caractéristique : des piétons flânent sur le Mall en direction du palais de Buckingham voilé aux regards par le brouillard, 1962.

p. 140/141

Elmar Ludwig

Traffic policeman at work near St Paul's Cathedral, mid-1960s.

Verkehrspolizist in Aktion nahe St Paul's Cathedral, Mitte der 1960er-Jahre.

Agent de police réglant la circulation près de la cathédrale Saint-Paul, milieu des années 1960.

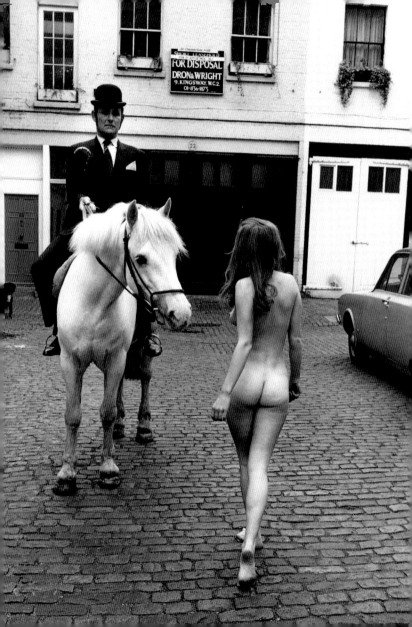

←

Frank Habicht

The public's idea of 'Swinging London', based very much on Patrick Macnee's role as John Steed in The Avengers *television series, late 1960s.*

Das Bild, das die Öffentlichkeit vom „Swinging London" hatte, wurde sehr stark von John Steed alias Patrick Macnee in der Fernsehserie Mit Schirm, Charme und Melone *geprägt, späte 1960er-Jahre.*

La perception de la Swinging London au sein du public dut beaucoup au rôle de Patrick Macnee jouant John Steed dans le feuilleton télévisé Chapeau melon et bottes de cuir, *fin des années 1960.*

↑

Lewis Morley

Christine Keeler, posing while embroiled in the Profumo Affair, 1963.

Christine Keeler, zu diesem Zeitpunkt bereits in die Profumo-Affäre verwickelt, 1963.

Christine Keeler, qui était alors mêlée à l'affaire Profumo, pose, 1963.

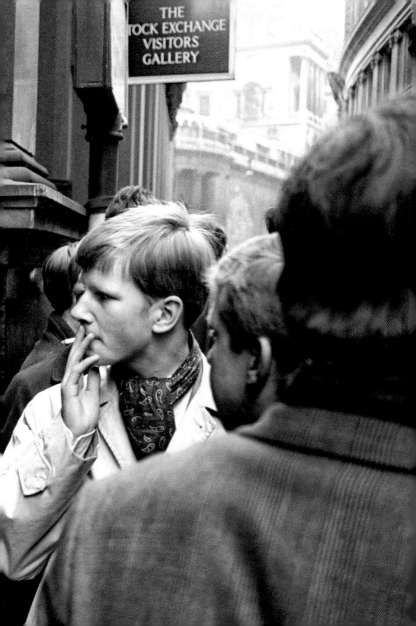

*"People try to put us d-down
(Talkin' 'bout my generation)
Just because we get around
(Talkin' 'bout my generation)
Things they do look awful c-c-cold
(Talkin' 'bout my generation)
I hope I die before I get old
(Talkin' 'bout my generation)"*

The Who, "My Generation", 1965

p. 144/145
Harry Benson
*A smartly dressed, confident young
man lounges outside the London
Stock Exchange, 1963.*

*Ein selbstbewusster junger Mann
im schicken Anzug, lässig vor der
Londoner Börse an die Wand gelehnt,
1963.*

*Un jeune homme élégamment vêtu,
très sûr de lui, s'attarde à l'extérieur
de la Bourse de Londres, 1963.*

→
Anonymous
*The queue of mourners waiting to
see Sir Winston Churchill lying in
state in Westminster Abbey extended
across Millbank to Victoria Tower
Gardens next to the House of Lords,
1965.*

*Die Trauernden stehen quer durch
Millbank bis zu den Victoria Tower
Gardens neben dem House of Lords
Schlange, um den in der Westminster
Abbey aufgebahrten Sir Winston
Churchill noch einmal zu sehen,
1965.*

*La file de personnes endeuillées
venues voir la dépouille de Winston
Churchill exposée à l'abbaye de
Westminster traversait Millbank et
s'étirait jusqu'aux jardins de la tour
Victoria, près de la Chambre des
lords, 1965.*

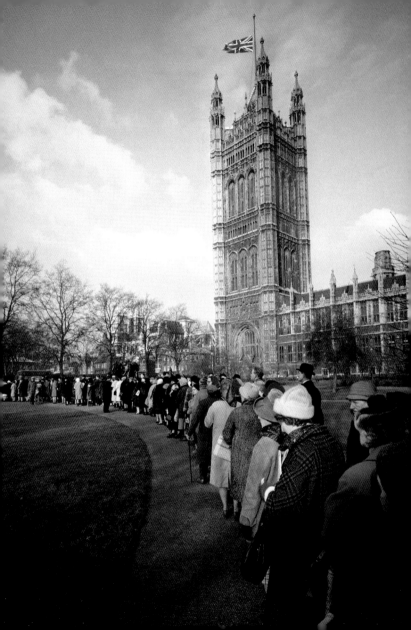

←
Edward Nagele

The Post Office Tower at night, now known as the BT Tower, is situated in central London in Fitzrovia, late 1960s.

Der Post Office Tower, heute BT Tower genannt, bei Nacht; der Turm steht in Fitzrovia im Londoner Stadtzentrum, Ende der 1960er Jahre.

La Post Office Tower de nuit. Aujourd'hui baptisée BT Tower, la tour est située à Fitzrovia, au centre de Londres, fin des années 1960.

↑
Anonymous

As autumn comes, a park keeper at Finsbury Park boating lake makes sure that no one will slip on the leaves, 1963.

Wenn es Herbst wird, sorgt ein Parkwächter am Teich des Finsbury Park dafür, dass niemand auf den Blättern ausrutscht, 1963.

À l'arrivée de l'automne, un gardien de parc près du lac de Finsbury Park s'assure que personne ne va glisser sur les feuilles, 1963.

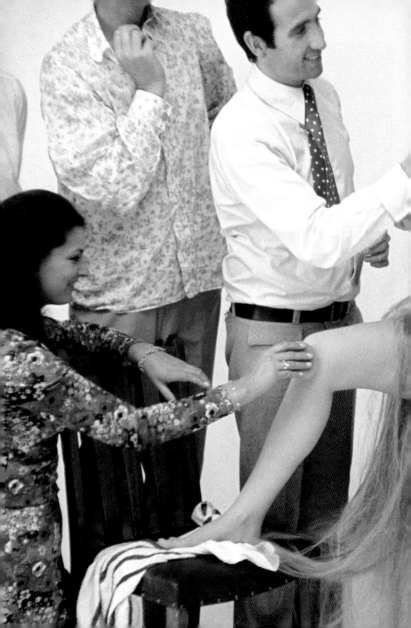

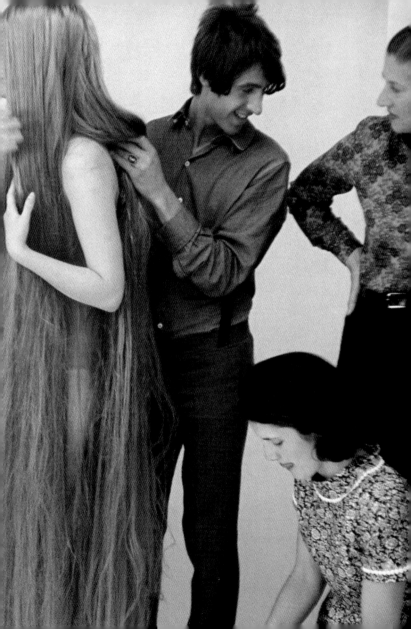

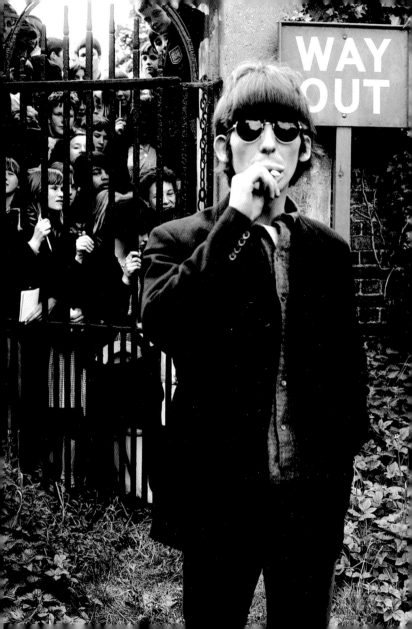

*"Come take a walk in sunny South Kensington
Any day of the week.
See the girl with the silk Chinese blouse on,
You know she ain't no freak.
Come loon soon down Cromwell Road, man,
You got to spread your wings."*

Donovan, "Sunny South Kensington", 1967

p. 150/151
Eve Arnold
*In the 1960s Britain became the
centre of youth fashion. In this picture
of a Norman Parkinson shoot, Lady
Godiva is wearing not much more
than a hair extension, 1966.*

*In den 1960er-Jahren entwickelte
sich Großbritannien zum Zentrum
für junge Mode; Lady Godiva trägt
auf dieser Aufnahme eines Fotoshoo-
tings von Norman Parkinson nicht
viel mehr als ihre künstlich verlän-
gerten Haare, 1966.*

*Dans les années 1960, l'Angleterre
devint le centre de la mode jeune.
Dans ce cliché pris lors d'un shooting
photo de Norman Parkinson, Lady
Godiva ne porte pourtant pas grand-
chose de plus que des extensions de
cheveux, 1966.*

←
Robert Whitaker
*George Harrison and fans, Chiswick
Park, 1966.*

*George Harrison und Fans, Chiswick
Park, 1966.*

*George Harrison et quelques fans à
Chiswick Park, 1966.*

↑

Philip Townsend

The 1960s look appropriated the clothes and artefacts of previous eras. I Was Lord Kitchener's Valet, at 293 Portobello Road, recycled Edwardian clothes, c. 1967.

Die Modemacher der 1960er-Jahre ließen sich u.a. von Kleidung und Accessoires aus früheren Epochen inspirieren. I Was Lord Kitchener's Valet auf der Portobello Road 293 verwertete zum Beispiel Kleidung aus der Zeit König Edwards VII., um 1967.

Le look des années 1960 s'appropria les habits et les accessoires vestimentaires de précédentes époques. I Was Lord Kitchener's Valet, au 293, Portobello Road, recyclait des vêtements de l'époque edwardienne, vers 1967.

→

Terry O'Neill

Photographer David Bailey demonstrates a pose to model Jean Shrimpton, c. 1967.

Der Fotograf David Bailey demonstriert dem Fotomodell Jean Shrimpton eine Pose, um 1967.

Le photographe David Bailey expliquant une pose au mannequin Jean Shrimpton, vers 1967.

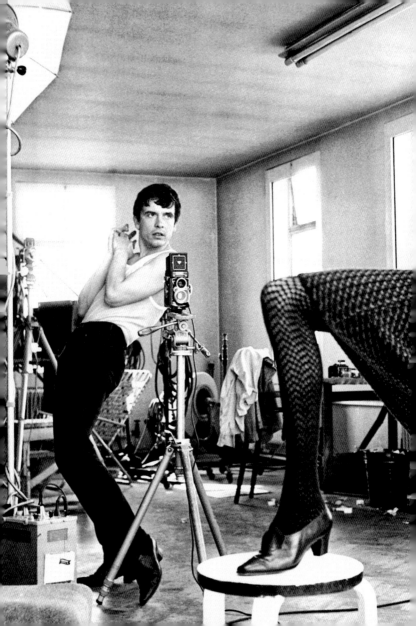

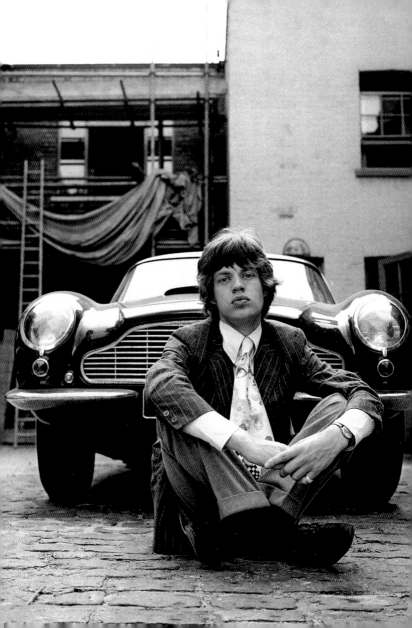

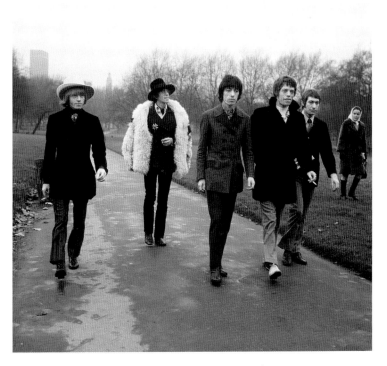

←

Gered Mankowitz
*A well-dressed Mick Jagger poses
in front of his James Bond Aston
Martin, 1966.*

*Ein elegant gekleideter Mick Jagger
posiert vor seinem aus James-Bond-
Filmen bekannten Aston Martin,
1966.*

*Mick Jagger élégamment vêtu pose
devant son Aston Martin modèle
« James Bond », 1966.*

↑

David Magnus
*The Rolling Stones in all their 1960s
finery parade on a January day in
St James's Park, 1967.*

*Die Rolling Stones, ganz im Mode-
stil der Sechziger gekleidet, marschie-
ren an einem Januartag durch den
St. James' Park, 1967.*

*Dans leurs atours typiquement
sixties, les Rolling Stones paradent
à St James' Park par une froide jour-
née de janvier, 1967.*

↑
Philip Townsend
*Charlotte Rampling in her dollybird
days, c. 1967.*

*Charlotte Rampling in jungen Jah-
ren, um 1967.*

*Charlotte Rampling encore un peu
fleur bleue , vers 1967.*

→
Bill Zygmant
*The original Apple Boutique, on
the corner of Paddington Street and
Baker Street, 1967.*

*Die ursprüngliche Apple Boutique
an der Ecke Paddington Street und
Baker Street, 1967.*

*La première Apple Boutique à
l'angle de Paddington Street et
de Baker Street, 1967.*

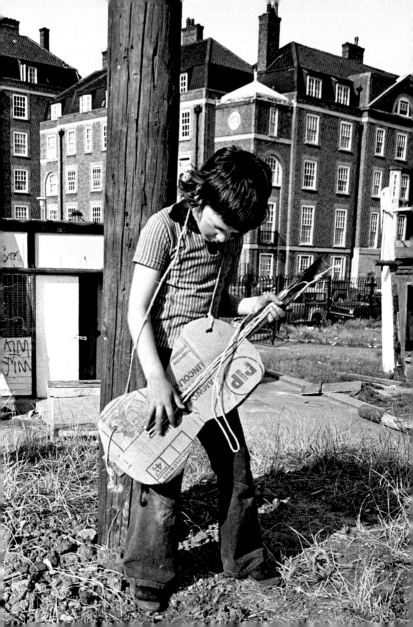

"There's a starman waiting in the sky
He's told us not to blow it
Cause he knows it's all worthwhile
He told me:
Let the children lose it
Let the children use it
Let all the children boogie."

David Bowie, "Starman", 1972

p. 160/161
Chris Morris
London's hippies were dubbed
'flower children' by the tabloid press,
because of their belief in the value
of childlike innocence. Their anti-
war, pro-love political message was
overlooked, 1968.

Die Londoner Hippies wurden
aufgrund ihres Glaubens an die
Bedeutung der kindlichen Unschuld
von der Boulevardpresse „Blumen-
kinder" getauft. Ihre pazifistische
politische Botschaft wurde völlig
ignoriert, 1968.

Les hippies londoniens furent
surnommés « flower children » par
la presse à sensations à cause de leur
croyance aux valeurs de l'innocence
enfantine. Leur message politique
pacifiste en faveur de l'amour n'a
pas été entendu, 1968.

←
Mick Rock
Dude 72 #2. *In London, rock*
musicians start young, 1972.

Dude 72 #2. *In London fangen*
Rockmusiker früh an, 1972.

Dude 72 #2. *À Londres, les rockers*
commencent jeunes, 1972.

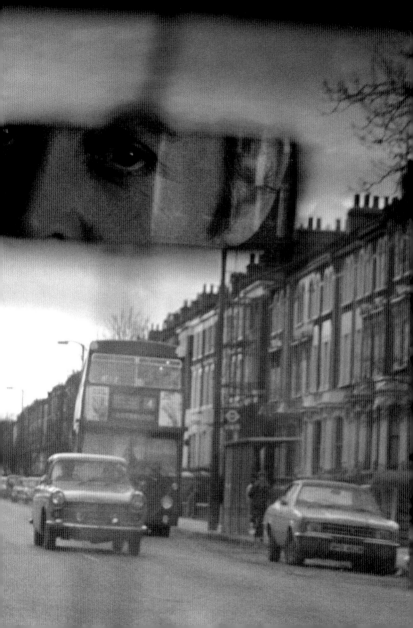

"London is where people go in order to come back from it sadder and wiser."

„Nach London gehen die Menschen, um trauriger und weiser zurückzukehren."

« Londres, c'est l'endroit où vont les gens pour en revenir plus tristes et plus sages. »

Martin Amis, *The Rachel Papers*, 1973

p. 164/165
Linda McCartney
My Love, *Linda McCartney's portrait of Paul McCartney in the rear-view mirror of their car. They used to get in the car and "try to get lost", which is not too difficult to do in London, 1978.*

My Love, *Linda McCartneys Porträt von Paul McCartney im Rückspiegel ihres Wagens. Die beiden stiegen oft zusammen ins Auto, um sich im Gewirr der Straßen „zu verlieren", was in London nicht allzu schwer ist, 1978.*

My Love, *portrait de Paul McCartney par Linda McCartney dans le rétroviseur de leur voiture. Paul et Linda prenaient régulièrement leur voiture pour s'évader et aller « se perdre », ce qui n'est pas trop difficile à Londres, 1978.*

→
Anonymous
A pregnant housewife shopping at her local store, 1970s.

Eine schwangere Hausfrau kauft im Laden um die Ecke ein, 1970er-Jahre.

Une femme enceinte fait ses courses dans un magasin de quartier, années 1970.

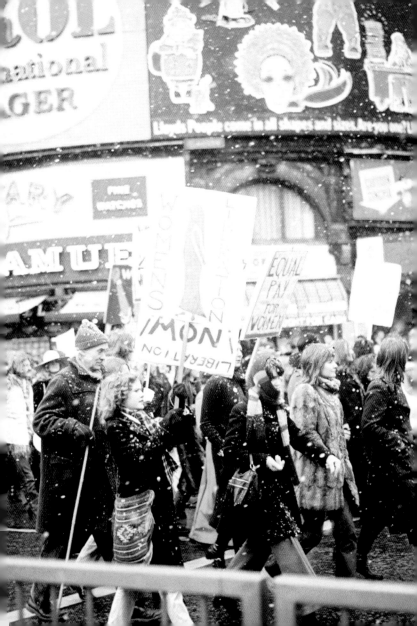

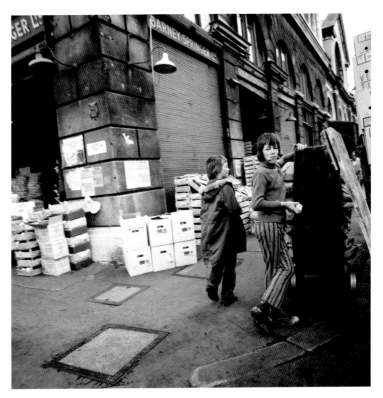

p. 168/169
Justin de Villeneuve
Twiggy, taken by her husband
Justin de Villeneuve at the Rainbow
Room, 1971.

Twiggy, fotografiert von ihrem
Ehemann Justin de Villeneuve im
Rainbow Room, 1971.

Twiggy photographiée par son mari
Justin de Villeneuve, au Rainbow
Room, 1971.

←
Clive Dixon
Participants in a women's liberation
demonstration brave the snow
while marching through Piccadilly
Circus, 1971.

Feministinnen trotzen dem Schnee
und demonstrieren auf dem
Piccadilly Circus für die Rechte
der Frau, 1971.

Une manifestation féministe affronte
la neige à Piccadilly Circus, 1971.

↑
Clive Boursnell
London kids working with the traders
at Covent Garden, London's central
fruit and vegetable market, c. 1972.

Londoner Kinder gehen den Händ-
lern in Covent Garden, dem zen-
tralen Londoner Obst- und Gemüse-
markt, zur Hand, um 1972.

Enfants de Londres travaillant avec
des vendeurs de rue à Covent Garden,
sur le marché aux fruits et légumes
du centre de Londres, vers 1972.

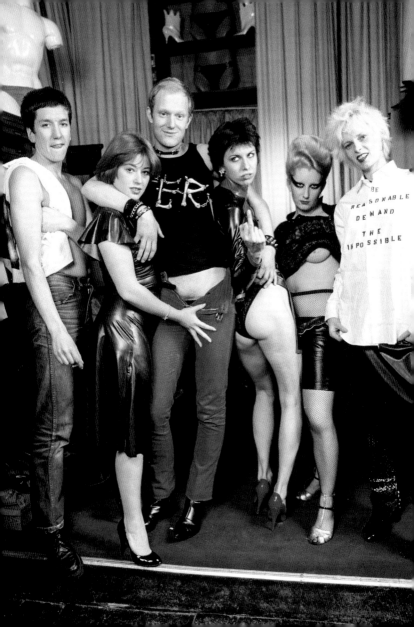

"London calling to the underworld
Come out of the closet you boys and girls."

The Clash, "London Calling", 1979

p. 172/173
Stefano Archetti

A light coating of snow in Hyde Park is not enough to deter these keen football players, most of whom are kitted out in shorts, 1977.

Von einer dünnen Schneedecke im Hyde Park lassen sich diese eifrigen Fußballer nicht abschrecken; viele tragen sogar kurze Hosen, 1977.

Une fine couche de neige à Hyde Park ne suffit pas à décourager ces footballeurs amateurs, dont plusieurs portent de simples shorts, 1977.

←
David Dagley

Vivienne Westwood's SEX boutique in May 1976 with (from left) future Sex Pistol Steve Jones, unknown friend, film writer Alan Jones, future Pretender Chrissie Hynde, SEX shop assistant Jordan, designer Vivienne Westwood, 1976.

Die Boutique SEX von Vivienne Westwood im Mai 1976 mit (von links nach rechts) dem späteren Sex-Pistols-Gitarristen Steve Jones, einer unbekannten Freundin, dem Drehbuchautor Alan Jones, der

späteren Frontfrau der Pretenders Chrissie Hynde, der Verkäuferin im Shop Jordan und der Designerin Vivienne Westwood, 1976.

La boutique SEX de Vivienne Westwood en mai 1976. De gauche à droite, le futur Sex Pistol Steve Jones, une amie inconnue, le scénariste Alan Jones, la future Pretender Chrissie Hynde, Jordan, l'assistante de la boutique, et la créatrice de mode Vivienne Westwood, 1976.

"London is my mother, source of most of my
 ambivalences and most of my loyalties."

„London ist meine Mutter, die Quelle der meisten
 Ambivalenzen und der meisten Zugehörigkeits-
 gefühle, die ich habe."

« Londres est ma mère, source de la plupart de mes
 ambiguïtés et de la plupart de mes loyautés. »

Michael Moorcock, *Mother London*, 1988

p. 176/177
Mike Wells
*As the Sex Pistols' critical "God Save
the Queen" reached number one
in the charts, most of the population
prepared to celebrate the Queen's
Silver Jubilee on a more positive
note, 1977.*

*Während die Sex Pistols mit ihrem
kritischen Song „God Save the
Queen" auf Platz eins der Charts
kletterten, blickten die meisten Briten
mit positiverer Einstellung auf die
Feierlichkeiten rund um das silberne
Thronjubiläum der Königin, 1977.*

*Alors que le très critique « God Save
the Queen » des Sex Pistols est au top
des charts britanniques, la majeure
partie de la population se prépare à
célébrer le jubilé de la reine sur une
note plus positive, 1977.*

→
Ted Polhemus
*The New Romantics loved
dressing up and created their own
subculture, 1981.*

*Die „New Romantics" liebten Mode
und schufen zu Beginn der 1980er-
Jahre eine eigene Subkultur, 1981.*

*Les Nouveaux Romantiques ado-
raient se saper et créèrent leur propre
subculture, 1981.*

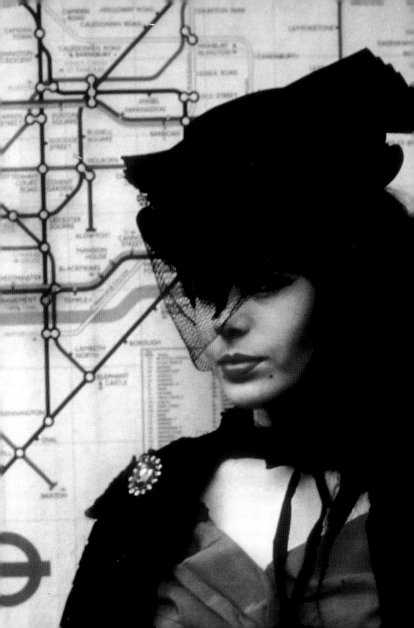

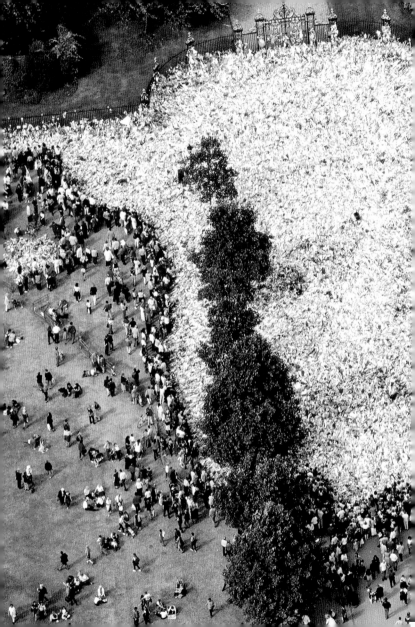

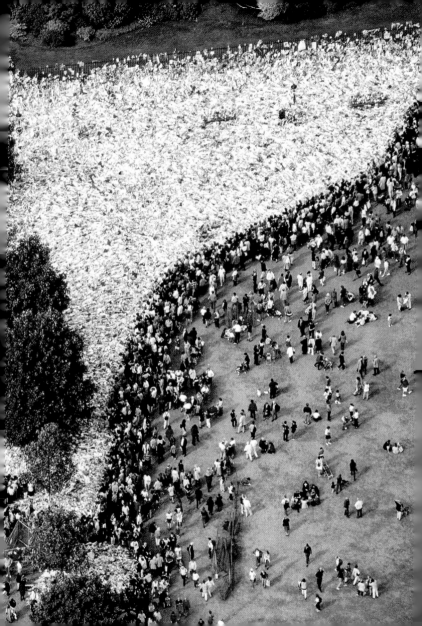

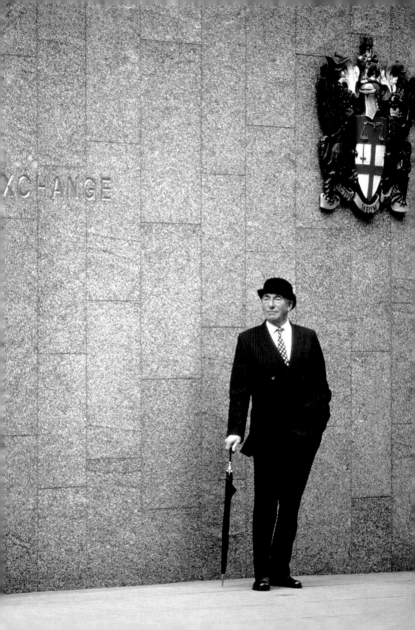

"*Smoke*
Lingers 'round your fingers
Train
Heave on – to Euston
Do you think you've made
The right decision this time?"

The Smiths, "London", 1987

p. 180/181
Peter Turnley
The death of Princess Diana on
31 August 1997 caused an extra-
ordinary outpouring of public grief.
By 10 September the pile of flowers
outside Kensington Palace was 1.5m
deep in places, 1997.

Der Tod von Prinzessin Diana
am 31. August 1997 wurde in der
Öffentlichkeit ungewöhnlich heftig
betrauert. Am 10. September hatte
der Blumenberg vor dem Kensington
Palace an manchen Stellen eine
Höhe von 1,5 Metern erreicht, 1997.

La mort de la princesse Diana le
31 août 1997 provoqua une immense
manifestation de deuil public. Le
10 septembre, l'amoncellement de
fleurs devant le palais de Kensington
atteignait 1,50 m par endroits, 1997.

←
Geoff Wilkinson
A happy city gent in his Savile
Row uniform outside the London
Stock Exchange, 1995.

Ein Gentleman in seinem Anzug
aus der Savile Row steht vor der
Londoner Börse, 1995.

Un gentleman dans son costume
coupé par un tailleur de Savile Row
devant la Bourse de Londres, 1995.

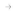 **Sarah O'Toole**

*Banksy's gallery attendant on
a garage wall in Drayton Park,
Highbury, 2004.*

*Der Museumswärter von Banksy
auf der Wand einer Garage in
Drayton Park, Highbury, 2004.*

*Le gardien de musée par Banksy
sur le mur d'un garage à Drayton
Park, Highbury, 2004.*

→ **Marcus Leith &
Andrew Dunkley**

*Danish-Icelandic artist Olafur
Eliasson's 2003 The Weather Project
in the Turbine Hall of Tate Modern,
which attracted more than two
million visitors, 2003.*

*Der dänisch-isländische Künstler
Olafur Eliasson schuf 2003 das
Weather Project in der Turbinen-
halle der Tate Modern, das über
zwei Millionen Besucher anzog,
2003.*

*Le Weather Project de l'artiste
danois-islandais Olafur Eliasson,
dans la salle des turbines de la Tate
Modern. Cette œuvre attira plus
de 2 millions de visiteurs, 2003.*

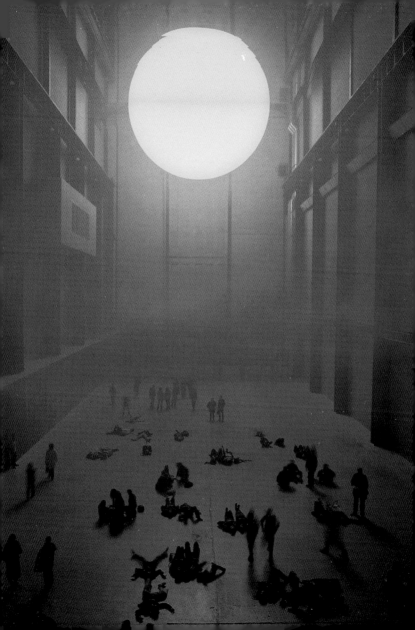

Photo Credits
Bildnachweis
Crédits photographiques

Any omissions for copy or credit are unintentional and appropriate credit will be given in future editions if such copyright holders contact the publisher. The publisher gratefully acknowledges the use of photographs provided courtesy of the following individuals and institutions.

© Slim Aarons / Getty Images *19, 105, 114–15*

© Clifton R. Adams / National Geographic Society / Corbis *60–61*

© Stefano Archetti / Rex Features *172–73*

© Archive of Modern Conflict *35, 72*

© Eve Arnold / Magnum Photos / Agentur Focus *150–51*

© Harry Benson *144–45*

© Bettmann / Corbis *40, 50–51, 98, 106, 367*

Between the Covers Rare Books *42, 49, 55, 67, 70, 79, 83, 93, 166*

© Werner Bischof / Magnum Photos / Agentur Focus *107*

Bill Brandt © Bill Brandt Archive *87, 97*

© Camera Press / Mike Wells *176–77*

© Camera Press / Snowdon *119, 120–21*

© David Dagley / Rex Features *174*

© DC Thomson & Co. *116*

© Clive Dixon / Rex Features *170*

© Terence Donovan Archive / Courtesy of Diana Donovan *130*

© Embassy Pictures / Photofest *127, 136*

© English Heritage. NMR / Heritage-Images / The Image Works *112*

© E. O. Hoppé Estate Collection at Curatorial Assistance, Inc. Pasadena, California *74, 75, back cover*

Courtesy Everett Collection *101, 137, 139*

© Larry Fink *131*

© Fox Photos / Getty Images *192*

© Peter Francis / PYMCA *122*

© John Galt / Museum of London *54*

© Frank Habicht *142*

© John Hinde Ltd. / John Hinde Collection *102–3, 123, 124–25, 140–41, 148*

© Estate of Evelyn Hofer *132, 138*

© Burton Holmes Historical Collection *4–5, 52, 62*

© Thurston Hopkins / Picture Post / Getty Images *96*

© Frank Horvat *100*

© Hulton-Deutsch Collection / Corbis *53, 90–91, 92, 118*

© Collection of K. & J. Jacobson *37, 39*

© Keystone / Getty Images *94*

© Library of Congress Prints and Photographs Division *45*

© City of London, London Metropolitan Archives *47*

© Gered Mankowitz / Bowstir Ltd. 2012 / mankowitz.com *22, 136, 156*

© Market Photos / HIP / The Image Works *171*

© Peter Marlow / Magnum Photos / Agentur Focus *29*

© Mary Evans Picture Library *11, 32, 59, 88, 109, 167*

© Herbert Mason / Daily Mail / Rex Features *86*

© Roger Mayne / Museum of London *113, 117*

© Paul McCartney / Photographer: Linda McCartney *164–65*

© Edward Miller / Keystone / Hulton Archive / Getty Images *134*

© Mirrorpix *2, 56–57, 78, 149, 175*

© Inge Morath Foundation / Magnum Photos / Agentur Focus *110–11*

© Lewis Morley Archive / National Portrait Gallery, London *143*

© Chris Morris / PYMCA *160–61*

© Museum of London *34, 36, 38*

© Harry Myers / Rex Features *25*

© Mystery and Imagination / Bookfellows *58*

© The National Archives, UK *46*

© National Railway Museum / SSPL *128–29*

© NMPFT / Kodak Collection / SSPL / The Image Works *80–81*

© NMPFT / SSPL *13*

© Terry O'Neill / Hulton Archive / Getty Images *155*

© Sarah O'Toole / PYMCA *184*

© PA Archive / Press Association Images *64–65*

© Norman Parkinson Ltd. / Courtesy Norman Parkinson Archive *cover, 126*

© Martin Parr / Magnum Photos / Agentur Focus *186–87*

© Ted Polhemus / PYMCA *169*

© Popperfoto / Getty Images *33*

© Mick Rock 1972, 2012 *162*

© Royal Photographic Society / SSPL *63, 89*

© Scheufler Collection/Corbis *6*

© Sean Sexton Collection / Corbis *43*

© B. Anthony Stewart / National Geographic Society / Corbis *95*

© Paul Styles / Museum of London *133*

© Wolfgang Suschitzky / Museum of London *82*

© Tate Images *185*

Quotation Credits
Zitatnachweis
Crédits des citations

© TfL from the London Transport Museum Collection 26

© Time & Life Pictures / Getty Images 84–85

© TopFoto / Ken Russell / The Image Works 14

© Topical Press Agency / Getty Images 68–69

© Philip Townsend 154, 158

© Peter Turnley / Corbis 180–81

© ullstein bild 71, 76–77

© ullstein bild / The Granger Collection 30–31

© V&A Museum, London 44, 48, 108

© Norman Vigars / Fox Photos / Hulton Archive / Getty Images 104

© Justin de Villeneuve / Getty Images 168–69

© City of Westminster Archives Centre 73

© Robert Whitaker 152

© Geoff Wilkinson / Rex / Rex USA 182

© Bill Zygmant / Rex Features 159

1 *Time* magazine, "You Can Walk Across It On The Grass". 1966

7 "Victorian Cities" (University of California Press, 1993)

9 Queen Victoria, September 1940

32 Charlotte Brontë, 1851, *Letters of Charlotte Brontë*, edited by Margaret Smith, vol. 2 (Oxford University Press, 1996)

42 Arthur Conan Doyle, *A Study in Scarlet*, 1887 (London: CRW Publishing, 2005)

49 Oscar Wilde, *The Picture of Dorian Gray* (London: Ward Lock and Co., 1891)

55 Robert Louis Stevenson, *Strange Case of Dr Jekyll and Mr Hyde* (London: Longmans, Green and Co., 1886)

58 Arnold Bennett, *Riceyman Steps* (London: Cassell & Co., 1923)

67 Joseph Conrad, *The Secret Agent*, 1907 (Oxford: Oxford University Press, 2008)

70 Evelyn Waugh, *Vile Bodies* (London: Chapman & Hall, 1930)

79 Virginia Woolf, *Mrs. Dalloway* (London: Hogarth Press, 1925)

83 George Orwell, *Keep the Aspidistra Flying*, 1936 (London: Penguin, 1963)

88 Reginald Arkell and Noel Gay, "Mister Brown of London Town", 1941

93 "The Lambeth Walk", lyrics by Douglas Furber and L. Arthur Rose and music by Noel Gay, 1937

101 *The Ladykillers*, directed by Alexander Mackendrick, Ealing Studios, 1955

109 Independent Television News Report, 1947

116 *The Beano*, D.C. Thomson & Co., 1948

122 *Alfie*, directed by Lewis Gilbert, Paramount Pictures, 1966

127 *Darling*, directed by John Schlesinger, Anglo-Amalgamated, 1965

139 *The Servant*, directed by Joseph Losey, Elstree Distributors, 1963

146 The Who, "My Generation", from the album *My Generation*, Decca, 1965

153 Donovan, "Sunny South Kensington", from the album *Mellow Yellow*, Epic, 1967

163 David Bowie, "Starman", from the album *The Rise and Fall of Ziggy Stardust and the Spiders From Mars*, RCA Records, 1972

166 Martin Amis, *The Rachel Papers* (London: Jonathan Cape, 1973)

175 The Clash, "London Calling", from the album *London Calling*, CBS / Epic, 1979

178 Michael Moorcock, *Mother London*, 1988 (Simon & Schuster, 1997)

183 The Smiths, "London", from the album *The World Won't Listen*, Rough Trade, 1987

Index

Numbers in italics refer to page numbers with images.

p. 2
Harry Dempster
Models wearing the latest mini-dresses by Paco Rabanne in front of a converted Routemaster, late 1960s.

Fotomodelle posieren in den neusten Miniröcken, entworfen von Paco Rabanne, vor einem umgebauten Routemaster, späte 1960er-Jahre.

Des modèles en minijupe dernier cri de Paco Rabanne posent devant un Routemaster aménagé, fin des années 1960.

p. 4/5
Burton Holmes
Central London traffic was as bad in Victorian times as it is now, 1897.

Der Verkehr im Zentrum von London war in Viktorianischer Zeit ebenso schlimm wie heute, 1897.

L'état du trafic à l'époque victorienne n'était guère meilleur qu'aujourd'hui, 1897.

p. 186/187
Martin Parr
Some punks kept their Mohican haircuts and lived by charging tourists money to photograph them, 1997.

Manche Punks behielten ihren Irokesenschnitt bei und verdienten Geld damit, sich von Touristen fotografieren zu lassen, 1997.

Certains punks ont conservé leur iroquois et vivent en demandant de l'argent aux touristes en échange de leur portrait, 1997.

p. 192
Anonymous
A photographer dangles over Fleet Street, with St Paul's Cathedral in the background, 1929.

Ein Fotograf über den Dächern der Fleet Street mit St. Paul's Cathedral im Hintergrund, 1929.

Un photographe surplombant Fleet Street, avec la cathédrale Saint-Paul en arrière-plan, 1929.

Front cover / Umschlagvorderseite / Couverture
Norman Parkinson
A Queen magazine fashion shoot, 1960.

Eine Modeaufnahme für Queen, 1960.

Photo de mode pour le magazine Queen, 1960.

Back cover / Umschlagrückseite / Dos de couverture
E. O. Hoppé
Advertising in Holborn station on the Piccadilly and Central lines, 1937.

Werbung in der Station Holborn der Piccadilly und der Central Line, 1937.

Publicité dans la station Holborn, à l'intersection de la Piccadilly Line et de la Central Line, 1937.

To stay informed about upcoming TASCHEN titles, please request our magazine at www.taschen.com/magazine, find our app for iPad on iTunes, or write to TASCHEN, Hohenzollernring 53, D-50672 Cologne, Germany; contact@taschen.com. We will be happy to send you a free copy of our magazine, which is filled with information about all of our books.

Editorial coordination: Reuel Golden, New York; Simone Philippi, Cologne
Art direction: Josh Baker, Los Angeles
Design and layout: Anna-Tina Kessler, Los Angeles
Production: Frauke Kaiser, Cologne
German translation: Ulf Müller, Cologne; Susanne Ochs, Heidelberg
French translation: Jacques Bosser, Paris; Wolf Fruhtrunk, Villeneuve-Saint-Georges
Collaboration: Jonathan Newhall, New York

Printed in Slovakia
ISBN 978-3-8365-4516-7

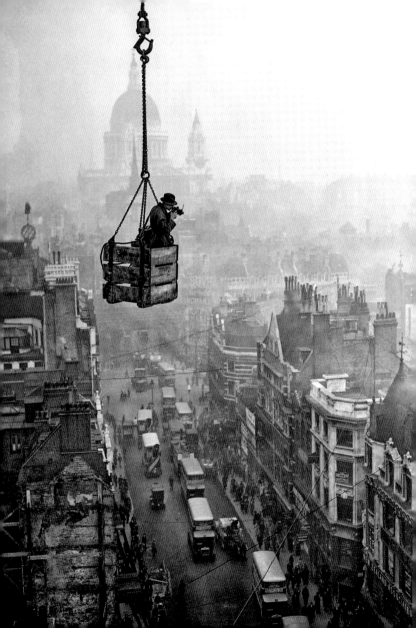

Take your pick—
or pick them all...

...the Piccolos© are coming to town!

Our popular *Portrait of a City* series is now available in the new Piccolo© format—192 pages distilling the best of the originals into pocket-sized books that won't put a dent in your wallet.